THE DREAMS OF
DONALD ROLLER WILSON

THE DREAMS OF
DONALD ROLLER WILSON

with a foreword by Ralph T. Coe

HAWTHORN BOOKS, INC.

***Publishers*/ New York**

A Howard & Wyndham Company

214463

Special thanks go to Bob Maygar of Gazlay Graphics, Kansas City,
Missouri, for his excellent guidance and assistance in preparing the
color separations.

Photography by James Butch Coger and Wade C. Kreie.

THE DREAMS OF DONALD ROLLER WILSON

Library of Congress Catalog Card Number: 78–65384
ISBN: 0–8015–0353–1 (paperback) 0–8015–0352–3 (hardcover)
1 2 3 4 5 6 7 8 9 10

The visions: The dreams of my waking hours are superimposed against an almost unbroken background of imagery. I have a threshold mind, assembling materials from several conceptual sources—frontiers—welding them together. But I don't know exactly what it is that moves the directions of my thoughts, and I wonder almost constantly about the shaping spirit that works through me. For there is some forming process accompanying me which sweeps like a selective magnet across an utter chaos of patterns in my thinking, and the result is that an otherwise aimless flow of associations—of mental wanderings—becomes documented. The documentations are what you see in my paintings.

I can say with absolute truth and authority that I am a bystander, and the things that stream together in my work set up a kind of subconscious communal existence of their own. And the only real control, on my part, is an ability to revive—voluntarily—that to which I have been exposed. Once, after an exhibition of my work in New York, I was quoted: "My paintings are reports which I bring home from my wanderings. They are maps." That's still true. And it will be my intent to keep you routed . . . so, gas up.

In the meantime, I dedicate this first book on my work to my rabbit, Kathleen, Freda the Wichita Blond, Judee (an estranged koala bear who likes hearts—too many as far as I am concerned), Ann, Patricia, and Betsy (three ridiculously rich and beautiful blond and smoking Texas cats). And a very special thank you to Betty Moody of the Moody Gallery in Houston, Texas, who has been helpful and loving beyond a point.

Donald Roller Wilson

WADE C. KREIE

FOREWORD

Before the term Photo Realism was ever coined, Donald Roller Wilson was steadily creating his works, first in Kansas, then since 1967 in Arkansas—beautiful paintings so unflinchingly realistic as at first to defy the fact that abstract art had ever existed. The imagination revealed in the content of Roller's work, however, is as metaphysical as anything being painted in America today. The presence of Art Nouveau in midwestern drag and the *belle epoque* inner archness, the genuine eccentricity, belong to Roller's vision alone.

I first became aware of Roller at the Nelson Gallery, where his work appeared in Mid-America Annuals of 1964, 1965, and 1966. The attention he received during these exhibitions led to an invitational full-scale presentation of his work at the gallery in the fall of 1970. One felt at that exhibition—meandering in that Kurt Vonnegut-like world of plausible improbability—that a new star was rising in the firmament.

"No one can paint that well today and really mean it" is a comment I have heard more than once from someone describing his works. "I can't believe it; it's just like switched-on Bach. It's all there, and because it is, it just isn't real." But Donald Roller Wilson does paint that well, through one of the most painstakingly sensual techniques that operates today—and in Fayetteville, Arkansas, of all places. Fayetteville seems to be to Roller what Indianapolis is to Vonnegut. And like Vonnegut, in *his* world, and in *his* hands, what appear to be familiar experiences fan into a madcap situation, out beyond where we can find firm footing. Everything goes counterclockwise, catching up in time, so that temporal matter disintegrates. The illogical, the genuinely scary, and the irrational *disjecta membra* mingle in a presentation so crystalline and appealing that, almost against our wills, we abandon our better judgments (our psychic barriers) and launch out into unknown poetics with a smile. His works are naïve to the point of absurdity, sophisticated to the point of genius, and as seemingly safe as our own mirror images, until we look to see what is really in the mirror. The unknown—albeit identifiable—lurks there. For a moment—for one clairvoyant instant—all of life becomes purgative distortion. Who else today paints the enigma of clairvoyance with such impeccable draughtsmanship?

Roller's brand of Realism challenges the conventions of contemporary American painting. He is obsessed with expressing the grand spiritual concerns of life, aims art-historically associated with the Abstract Expressionists who isolated and used as their means and subject matter only the most formal and abstracted elements of painting—color, light, space, and the physicality of paint itself—to elicit the unknown and perhaps unknowable. Wilson, though, jolts the viewer with his juxtapositions of identifiable objects and fantastic characters in familiar settings. But he's not like most other Realists either. His world is not comprised of the stark, photographic vistas of the Photo Realists; nor is it an idealized Romantic vision; nor is it exclusively a figurative presentation of allegories as in Narrative or History painting. Wilson shares something with all of them—the precise painting, the dreaminess, the moral tales—mixing them together with such intensity and control, humor and terror, that while we can identify individual parts, we can't make them make sense in combination as a whole.

"I'm interested in helping the average man get out from where he is and get over to the other side. To elicit this response, I can't use Rothko's space. For me, it's a particular object or group of objects that signal my experiences, always spiritual, incorporeal, mystical, whatever you want to call them. I know there

is danger in interpreting those objects—they are also subject to the viewer's experience.''

Considering the plethora of objects and characters—props and persona—in each painting, there is always much more than meets the eye; we are drenched with associations that occur in and out of their contexts. Roller's apes, pears, zebras, skeletons, rag dolls, cuts of meat, and real people are exactly what they appear to be, plus more. That multiplicity of meaning is central to his vision: He is occupied with the means by which one thing—one action or situation—can be seen to be another. And he is master of the merged vision; his juxtapositions of parts elaborate and contradict each other. He presents the facts, but we must fill in the gaps—the ''becauses''—that complete the activity and transfer it mentally beyond its original scope. Each painting presents a complex assortment of information, but we must determine the meaning as a whole.

We are not left completely to our own devices, however, in digging for what he is saying. His elaborate titles are notes, clues to the mental states that made the paintings possible; and often a title is written down long before a painting is begun. An example:

THE DESTRUCTION OF A WHITE HOUSE ON THE PLAINS

THE HEAD OF STATE—HIS HOLLOW BONE,
A WIND HAD SHED HIS SKIN;
A WHIP—A THIN BLACK WHIRLING AIRBORNE CONE

BUT LITTLE COOKIE LEASHED HER GOOSE
TO SAVE IT FROM THE WIND;
THEY WAITED ON THE STEPS BELOW THE THRONE

These literary passages—almost poems—outline what there is to be seen. (Roller, in fact, is very much the writer, using puns verbally as well as visually.) But we must take the title and painting together, for what he aims to do is capture the simultaneity of all phenomena. Things change—they die and are born again—yet the painting remains as a succinct record.

LIFE IN FAYETTEVILLE

Donald Roller Wilson moved to Fayetteville, Arkansas, as a professor with the University of Arkansas in the fall of 1967, expecting it would be a short-lived venture. And as everyone does who comes from the ''outside'' world, Roller anticipated hillbillies on porches with guns and dogs and stills. And they were there. They still are. Roller is still there too. After his eight years as a professor his career as a painter demanded that he become a full-time painter, which he has been now for four years. That he continues to live and work in Arkansas is surprising to many in the art world. But Fayetteville is to Donald Roller Wilson what Indianapolis is to Kurt Vonnegut.

To the townspeople, Roller and Kathleen Wilson are very real fellow citizens. What Roller does in the isolation of his studio is strictly his own business. There used to be no telephone (Roller begrudgingly had one connected recently due to complaints from ''civilization'' that he was too unreachable). Few art critics venture near. Thus he lives between his prosaic everyday life and imaginative echoes of *Deliverance*. The table at home is beautifully set for dinner, the house impeccable and elegant, the hours regular, the empathy—quiet and kindly. But, there is no painting by Roller in his house, except for two miniature landscapes in tiny original Art Nouveau frames shelved along with the rest of his collection of turn-of-the-century arts and crafts. To bring in his own paintings would be dangerous, like a fatal mixing with things best ignored. ''My real world is in those paintings; I live as straight as I can on the outside so that in the paintings I can be free. If I allowed myself to be as the paintings are, I would wither. I am absolutely alone with my interpretations and suspicions of the world—the universe—out there, in there . . . until I discover that what I 'feel' is not unique, but shared.''

Fayetteville is also important as a source of props for Roller's paintings. Everyday items, including the stuffed animals, rag dolls, and sock monkeys, produced by the Arkansas rural community, are his models. Their use, though, also seems part and parcel

of Roller's desire to love and communicate with everyone. Various Fayettevillians have also been inspiration for his personae and often pose for him. Though some of his neighbors suspect he is a ''star,'' many do not know exactly what it is he does. ''My original studio used to be over Brown's Seed Store. It was during the times when I was painting the large ape paintings. And when I would haul them down to street level in order to crate them for shipping, Mr. Brown would always come out and make himself available as a critic. He thought I did circus billboards, and being comfortable with his appraisal, I lived with it. He still thinks that's what I do, even though he is retired now—and I have moved.''

Roller's love affair with Fayetteville continues. It seems almost as if his paintings are sent out into the art world as monitors from the spirit dreamworld of Arkansas.

THE PERSONAE AND PROPS

Roller is a playwright who does not write plays. He paints his thoughts—his scenarios. And if the reader/viewer has not enjoyed an introduction to the personae, then he could very well be lost before he takes the first step into Roller's cosmos. The world of these characters is a preternatural world to be sure; they see us as others see us, and watching them is like reading a book about ourselves that was written on another planet. It is quite a show, this reversal of roles, and is accomplished with wit, extravagance, diligence, and gusto. And needless to say, it is all elegantly painted.

The Monitor/Creator

Roller makes extensive and frequent use of what seem to be monitors in his pictures. They are watchful, mysterious, creative forces, sometimes serving as information gatherers, that may or may not be visible. God the creator, in Roller's eyes, has the ability to

change form—disguise himself, as it were, in order to be in a position where he can "keep tabs."

Sometimes the hand of the monitor/creator appears as master of ceremonies at an old theatrical. His hand holds the spotlight at the far left in THE MAN HAS LEFT THE MOON TONIGHT (page 81); he reappears in the background sailing witchlike across the pale moon sky—"one of his more spectacular appearances." In other pictures he tweaks a bunch of grapes serving as an ape's hat-headdress or ionizes a box of Aunt Jemima mix with a purple light emitting from a cathode tube AUNT WHITE AND MISS JEMIMA (page 111). Actually, he has been with Roller a long time, this creator/force. "I didn't really know it at the time the way I do now, but he was the face in MERCY LANDS CRIED JACK! (page 125)." The glowy objects and bath beads in the pictures of 1970–71 were additional evidence of his omnipresence (RIVERBANK: DEAR WICHITA RABBIT, page 121). Furthermore, it is he who is responsible for the starlike dust on the apple in TWO SWEET SINGERS IN THE WOODS (page 99), who floats those slices of cantaloupe in various pictures and puts the dew on the lips of those apes. "The more you look, the more you will find him around. He is a human shadow on a table mirror in SUNDAY SINGER (page 101)." But he is not revealed openly because there's no need to, like the Supreme Being abstracted in primitive religions. "The more I paint, the more I recognize what he is up to. You know, Mozart said he felt as if he were being guided. I know exactly what he meant."

For example, in recent pictures the monitor/creator has become very adept at opening drawers in nightstands, and it is he who shines the headlights from offstage on the picnic scene, MRS. WHITE HAD PARKED HER CAR (page 79). When in doubt about a Donald Roller Wilson painting, look for evidence of the monitor—this auto-suggested transcendental force which takes and sends as many guises as there are apes in the woods, cows in the field, or grapes in the sky. New uses for the monitor/creator continue to surface. In paintings of 1974 through 1977, the monitor has appeared as a specimen jar, or jug filled with "universal brew, a kind of heavenly stew made of all the possible elements (physical and/or spiritual, non-material) in existence. It is a kind of "kit," or "storehouse of supplies," that has been sent by the creator to his "children"—much as a mother would pack a lunch for her child so he would not starve."

Mrs. White

The first ape-human (her premier: August 1971). She is the matriarch, reserved, a little stiff, the mother figure. No one puts anything over on her (though Little Betty sometimes succeeds in annoying her).

Little Betty

Roller's voyeur. She is a tease, a sort of trickster. In LITTLE BETTY PEEKS AT MRS. WHITE BATHING (page 109) she uses a telescope to spy on Mrs. White (unseen). We are really witnessing a part of Roller's clandestine self—though Roller is quick to remind us that Betty is actually looking through a kaleidoscope (insisting on the multiplicity of vision, fragmented as it may be, rather than a single focus); that Betty doesn't know the difference; that she just imagines she sees Mrs. White. (In a series of very small late paintings, one occasionally encounters Betty's friends—Richard and Lois, as well as her brother, and her sister, who is frequently drenched in fruit juices.)

Aunt White

Aunt White is the fulcrum in Roller's imagination and the most flexible character. "If I were a writer and Aunt White were a word, that word would encompass completely what I know about the total limits of absurdity." (See AUNT WHITE SINGS AND PUSSY LISTENS, page 103.)

Betty Jane and Hazel

The nieces of both Mrs. White and Aunt White. They are sisters. Betty Jane is the brighter of the two and is the one who always has dates. Hazel is not very bright at all, but she worships Betty. (See TWO SWEET SINGERS IN THE WOODS, page 99.)

Chigger

A *very* complex black woman/girl who travels backward and forward in time (usually accompanied by a ghost cow), ignoring and flouting any definitions of the mechanics of reincarnation. (See LITTLE SHIRLEY WARMS HER SHOULDER ON THE TEAPOT, page 89; LITTLE CHIGGER HUGS AUNT WHITE, page 97; and SUNDAY SINGER, page 101.)

Gladys Atlas

Gladys is the white human reincarnation of Mrs. White and/or Aunt White (see THE MAN HAS LEFT THE MOON TONIGHT, page 81). Gladys also has been seen as a skeleton (GOING; COMING—THROUGH A WINDOW, page 71). In real life, Gladys Atlas is Glorya Sanders. Glorya owned the Atlas Van Lines Company which, at one time, was located in the same building as Roller's studio. She posed for the painting THE MAN HAS LEFT THE MOON TONIGHT (page 81), one of Roller's finest works. Roller is convinced that "Glorya is a white witch—a wonderful power figure in my life."

Little Cookie

An orangutan version of Little Betty. In fact, Cookie and Little Betty are very close friends. Cookie, like Betty, has many naughty friends, including a veritable raft of smoking cats.

Shirley

Shirley is the star of many paintings, and when she's not, she's an important bit player (see IN MY DREAMS SWEET PAPER PIG, page 83; THE DOG BY THE LAKE ON THE WALL OF MY ROOM, page 75; and THE ENTRANCE OF SHIRLEY INTO PARADISE, page 63). Made from scraps and leftovers—socks, a lady's dress, stuffing from an old hotel mattress, buttons for eyes—she is a visible indicator of philosophies that are private to the artist.

Shirley really gets around. And because Roller uses the image of Shirley so compulsively (usually she is included as the silent observer, another monitor, perhaps) she must be an important signal. Another point about Shirley—she never changes (however, in a very recent picture she LOST HER RAG-DOLL HEAD—BUT GAINED A REAL ONE (page 21). She is always dressed the same, always maintaining the same neutral position. She knows a lot, but she is mute, safe to have around.

In one painting featuring Shirley (SHIRLEY WATCHES AS SOME RIDERS RIDE IN ON A ROLLER SKATE, page 69) she is seen (dumbly?) watching a jar of olives which are "having a ride" on a roller skate. In the complete title there is the implication that, while most of us think that olives come from "stores," Shirley knows how they really get here: SOME MAY THINK THEY COME FROM STORES BUT SHIRLEY KNOWS ABOUT THE GATE.

Shirley, to Roller, is more than a persona (and one should be very careful to know that all Roller's characters are more—just generally more—than that which they appear to be). Roller has let it be known that we should be cautious in interpreting Shirley or any of the characters and objects in his work as symbols.

"When the viewer looks at my work he will interpret what he sees on a level that is in agreement with his usual daily or operational level of interpretation. I mean, when an 'ordinary' guy looks at a Wesson oil jar in the Safeway store, he thinks to himself—Wesson oil! Farther down the aisle he spots a box of batter mix and thinks, batter mix! So, arranging his thoughts about

those things in juxtaposition, he heads for the chicken in the meat counter, fully expecting that the conclusion of his efforts will be a logical exercise in which he batters the chicken and frys it in the oil. Furthermore, if the same guy sees a bottle of Wesson oil in a composition of mine, he is going to think, Wesson oil! That is a mistake and a serious one, because my frame of reference, even during a stint in Safeway, is vastly more open-ended. When I see the bottle, it is a most reliable fact that, instead of conceiving of the bottle as an agent that will lead me to the batter and the chicken, I am literally seeing through the bottle, on to the Aunt Jemima box which is adjacent to or behind the bottle—and the "Aunt" has turned from dark brown to amber—because of the coloration of the oil inside. And, simultaneously with seeing through the bottle I am equally concerned with the reflections on the surface of the bottle which allow me to see not only my own self—my own reflection—but perhaps the door of the store behind me through which I entered. So, my experience in that instant has to do with time, reality (visual), space, distortion, etc. And when I use the image of an oil bottle filled with oil in a painting and the bottle is juxtaposed with a framed photograph of Little Chigger and a blood specimen jar, I am not making a symbolical reference / comparison between Chigger, the oil bottle, and the jar. If the viewer thinks that, then he may be better off setting up camp at Safeway—because it's safer than dealing with me! I'm dealing with psychic elements, not fried chicken."

One is reminded of Redon's dictum of making the visible serve the invisible, except that in Roller's case the imagery—the props or personae—are not themselves subject to material distortion. There is no open, or immediately visible, monstrosity in his cosmos. Items in Roller's paintings are all in focus, all identifiable, all "safe" (when viewed separately). But the communicative magic occurs when he combines a lot of pictorial elements (his signals), themes, and concepts. The components, for example, of one of his luscious still lifes are often diametrically opposed in terms of "meaning" or "function." But the tension of these incongruities creates a responsive aura, a sort

of psychic ether. Sometimes it is indicated by a glowing aura surrounding objects, whether animal or mineral. It becomes clear that "nothing in those pictures takes place on earth . . . I'm not (as a painter) worried by anything nebulous.

"Painting is antithetical to what I'm working with, but the brush can imply so much . . . there are moments (in my paintings) when you can step out of circumstance and see your point of origin, the place you came from and are going to."

A really successful work by Roller embodies all of this. Less successful ones hint at it. Just exactly how depends on what level you bring to bear against the imagery—like clairvoyance between souls—the shock of self-recognition in the fluid state. "You will have the capacity to know the instant this state occurs that my work is not real at all, has nothing to do with the items, but with the connections, the conjurings. Ordinary people will say, 'How real!' They are served. The thinking person (in that state of clairvoyance) will know that I made the best effort I could to find out about things that, solidly, are ephemeral, that own to other existences, that, like us, come materially to nothing, rejoin the elements—in the dark, in the mirror, from the other side. We strive to join those elements; they don't strive to join us."

Roller is at ease among his objects and characters, watching their psychological turns and aberrations like a musing, indulgent parent. Part of one character can inhabit the flesh of another. He often speaks of them as if they were alive.

It is to Roller's credit that he is able, by applying reality, to get under its skin, looking through the epidermis, the cool texture of superbly realized appearances, into the psychic fluidity of our cranial and subconscious yearnings and predestinations. In his hands even what is most prosaic has the potential of high imagination. (Often Roller says he feels close to Bosch. Like his sixteenth-century mentor, he paints huge scenes involving the most complex planning, lighting, settings, and characters. He begins where realism, as we have understood the term, stops. "There is still whimsy in my painting, but now only like

a bay leaf in a pot of stew. Now I can paint straighter in order to be more metaphysical, philosophically. The subtleties coexist more closely in what I do now.''

THE GREAT APES

The sources of Roller's Great Ape series can be seen in his paintings of 1968–69: MERCY LANDS CRIED JACK! (page 125) and PEA KING—OF THE MOUNTED STAR PATROL (page 123), the earliest paintings in this book. They have a vignettelike format with very little illusion of depth. In PEA KING, the Thalo green peas in the heavens bulge like a turgid rain forest; the dizziness of the whirling planet and the nebulas are coequal with the zaniest of the apes. (The inspiration of these apes was Snowflake, the world's only white gorilla, pictured in *National Geographic,* March 1967.)

During the years 1969–71, Roller was manicuring his craft. Though educated, he is self-taught. He had attended school during the last throes of Abstract Expressionism, and not wanting to ''dabble around,'' he made almost a religious habit of isolating himself and finding out as much as he could, wherever he could, about technique. He was interested in Maxfield Parrish long before the present-day revival of interest in Parrish. ''I was aware of him in high school. There was a vacuum in his skies, something ambivalent about the sex of his figures.'' To this day there is a book on Parrish on Roller and Kathleen's bookshelf given to him by his aunt when he was a teen-ager. The skies in the color frontispiece are diagnostically proto-Roller and seem to presage even those strange arcadian groves which provide settings for some of Roller's most memorable and outlandish pictorialization of 1969—70. In them, memories of the Civil War cemetery near his home in Fayetteville, a sort of garden of unearthly delights for him, mix straight-on with Faulknerian decadence.

In the paintings of 1969–71 the previous flat format of presentation was gaining depth. The meandering lines that had divided his compositions were giving way to a new means of dividing—rather defining—the picture plane. His subjects were now held in check and presented in showcases created by floating slabs of grained stone and marble (see HOLSTEIN—BLACK SWAN, page 115; and COLD NIGHT; MY RABBIT—ME—A FRIEND, page 117).

By 1971, even this approach seemed crutch-like—like using stage props. Roller's concerns, after winning some difficult bouts with design and technique, became centered on the development of his personae, the most important of whom we have already met. In addition there were the Baroness Starstruck di Supernova and a host of others. They were like characters pursued by a dramatist. They fully invaded the pictures, overturning the props, while still lifes continued to blossom full tilt. He began to handle full-scale grandiose presentations with baroque self-assurance.

In conversations I had with Roller during those years, he indicated that he was experiencing a kind of philosophical awakening. ''My giving of animate faculties to inanimate things, the ability to subscribe to the momentary possibilities of life, may be the result of a desperate wish to witness dramatic and supernatural proof that this seemingly locked-in, frozen-up world can suddenly put on a gold lamé drum major's outfit and do a tap dance.'' When looking at Roller's use of fabrics or his succulent still lifes—each apple, Jello mold, or lily bouquet, even the stunning jewelry worn by Mrs. White or her sister, Aunt White—''you realize that the fact of what you are, compared to what an inanimate object is, may very well be caused by a lack of faith within yourself that the object is not alive.''

Roller's personae of 1968–70 *looked* like apes, but the succeeding generation—the Great Apes—of 1972–73 passes into the world of humans. In the fall of 1972, Mrs. White and her sister consented to sit for two consecutive monumental canvases (pages 103 and 101) that would make a Titian expert smile or groan, according to taste. The titles:

AUNT WHITE SINGS AND PUSSY LISTENS;
FRESH FROM MARKET: SUNDAY GOOSE
IN THESE WOODS WHERE MY HEART LISTENS,
TIGER HISSES—GLASS BALL GLISTENS

And,

SUNDAY SINGER—(MRS. WHITE);
TIGER JOIN IN—SOUND A FRIGHT;
LITTLE CHIGGER CHEW A FINGER,
JACK-O, JELL—(OH! COMING NIGHT)

The earlier of the two AUNT WHITE SINGS shows Aunt White seated in an overstuffed chair to the left, rich curtains behind, absorbed in bel canto: ''really belting it out.'' One almost expects to see Holbein's Turkish ambassadors approach from the rear, were it not for the bayou with its mysterious chromo effect; or could this be Augsburg at the time Titian painted portraits there? ''I identify with Rousseau jungles much more than with Rothko, but I put it all in a bell glass jar.'' The little cat/doll opposite Aunt White is all ears, waiting, having returned from market, basket and umbrella in hand. Waiting for what? To cook the goose. of course, But the tiger rug hisses, the glass ball glistens.

The bayou penetrates through the curtains, reflected in the ball and oval mirror frame beside Aunt White. There is something Victorian, almost macabre, in this overstuffed world where ornamented curtains crinkle and antimacassars groan. Captain Nemo's salon on the *Nautilus* could not have been more bizarre. The deep curtain folds seem auricular, listening to the song. However jaded the arrangement, no one can doubt the masterful attainment; this picture recalls a great baroque altarpiece in size and is a worthy successor to the genre.

The other huge picture executed at this time, composed lengthwise, actually contains the word *fright* in the title. Now the tiger rug ''joins in sound a fright.'' Little Chigger (seen here as a young girl) can hardly resist stopping her ears. The song is so well-known to Mrs. White that she can ignore the score.

Even her plumes are atingle with vibrations. Mrs. White reclines—"Olympia"-like—as she arrives at the ultimate exhalation (or read the ultimate miscue, undetected by the miscreant). The floor sweeps unbelievably upward; the tables are set out of focus, as in AUNT WHITE SINGS (page 103); those who might be inclined to dismiss the slickness should look carefully at the deliberateness of effort in the distortions involved in Roller's detail work. Everything floats, like a table rapping at a séance, "though how all those silks and velvets and trappings got off the ground is a mystery to me," says Roller.

It is true, these apes can best elicit our responses as they are caught in the act of singing. But what are they singing? Singing in the woods has deep-rooted associations. "As a child I'd roam in the Texas woods at Huffman near Houston; they were safe to me; I've always trusted woods. But the cows I was afraid of. My mother advised me to sing to them, and everything would be all right. I'd sing to them and tell stories." Is Mrs. White singing a cow song as she reclines? Who *really* knows! It occurs to me that on the surface of a very recent painting (THE CLONE; THE FUSE; AND SISTER DINAH MIGHT, page 29) Roller has signed "THE DOG NOSE." It must be the dog who "nose" the song. Conversely, Aunt White, in AUNT WHITE SINGS (page 103), sings a "real light French operetta by an Italian ape who is thoroughly confused about syntax."

Since 1972, this arbored fantasy has merged with the live oak vistas of Houston, where Roller was born and to which he regularly returns. Standing at the window in a River Oaks Houston mansion one sees echoes of the crepuscular vine rope and live oak bayou behind the curtains in a Roller Wilson picture twenty feet away across the dining room. And Roller is not finished with the apes—completely. Though the Whites show up infrequently nowadays, they are still around. Who knows, "they may show up, later, attending the funeral of Gladys Atlas! Did you know my friend Glorya is moving back to Fayetteville and I can use her again in a painting that I planned months ago?" The title has been pinned to Roller's studio wall since 1975. It reads:

THE NIGHT THAT GLADYS ATLAS DIED
THE WITCH WHO PASSED THE MOON
THAT NIGHT SO VERY VERY LONG AGO

SENT WORD THAT SHE COULD NOT ATTEND
AND SENT HER HAT INSTEAD
WHICH TOPPED THE SPIRIT AS IT LEFT TO GO

ONE HEAD OF STATE WAS ON THE BOARD
THE IRON WAS STEAMING STILL
IT WET THE DRESS OF SHIRLEY AT THE SHOW
SHE KNEW THE MAN OUTSIDE, THAT NIGHT, HAD HAD NO FACE TO SEE
BUT GLADYS LOOKED FOR SOMEONE SHE WOULD KNOW

"Do you remember that baby carriage I pointed out to you at the junkyard? Well, I've got it. I want it in the painting with a chimpanzee in it, and the coffin with Gladys in it, smoking two cigarettes, wearing a witch's hat, eating an elaborate meal on a tray." This is all a good example of the mind-searching that goes on *before* a picture is begun and which accompanies the finished work forever. It is almost ironic that Gladys is coming back.

It has been my experience that one level of reaction to certain of Roller's canvases is not free of the suspicion that racial or political overtones are in the air. There is a reference—indirect—to the gesture and abandon of the black world, but the result is white—white all over. There is nothing demeaning, let alone political, intended. To know Roller is to know he is nearly unaware of social commentary and no student of it. He doesn't know how to handle a racist remark, let alone recognize one. This should be borne in mind in view of Aunt Jemima, Jesus, or a Japanese nurse turning up in his pictures. If the joke is anywhere, it is on the human condition, exposed by the process of "aping."

THE STUDIO, THE METHOD

Roller paints from environments constructed in the corner of his studio, sometimes on a stage, which he has patiently arranged and dressed like store-window displays. He turns off the overhead lights when he works, using only the light from a single fixture trained on the surface of his canvas. Does Donald Roller Wilson think about Honthorst or Caravaggio? "No, I just darkened the studio and painted in the dark. Kind of Victorian, isn't it?" Hard-core Victorian painting was spiritual, and Roller is definitely a spiritualist.

The studio setup can be incomplete; part of a dummy or a drapery swatch hung as a sample, or the model, having done her share, can be absent. In several 1974–76 pictures mannequins or skeletons are depicted rather than people. Perceptual acuteness demands that these models and paraphernalia be isolated for psychological distance yet be grouped for compositional harmony. The tension between the two becomes exponential. The arrangements are as studied as in a daguerrotype. Concentration is total. Not a pin drops. Everyone keeps away. Something lurks in the meticulously clean silence.

Prior to a New York exhibition of Roller's work, which was held during late 1975, I visited Fayetteville to inspect the series of canvases firsthand. When I first saw these pictures, I thought he had set foot on a road away from modernism. They reminded me of salon paintings—"machines." But I was in error. The more old-masterish the format, the greater the escape route "out there."

"I feel that there is always the danger that my work is too clear to be seen—and I know that sounds like a paradox. But quite often it has been my experience that when even a 'trained eye' roams over the surface of my work, it is blinded by the technique—doesn't see the message." Perhaps one would have to be blind in order to *not* see the message.

Between 1974 and 1976, some of Roller's painted meetings and encounters have taken place in a number of atticlike or lonely rooms, cobwebbed with musty fantasy, but crystalline in light, impeccable in texture. The feathered brushwork has given way to a straight handling of paint, but with a lighter touch, drier auras, delicate aromas. Or most remarkably, a moonstruck forest grove in which the players as-

semble and are caught with studied seriousness, for all their startled or casual airs. They are caught unaware, or are they cued? The last laugh is on us in either case.

We find ourselves readily accepting the patently impossible, while no longer taking anything for granted. MRS. WHITE HAD PARKED HER CAR (page 79), for instance, offers Mrs. White with a paper bag on her head, not seeing what we see; the very French poodle with her in the woods, crown jauntily askew with cigarette dangling from the mouth (it must be a Gauloise), the filled specimen jar, and the acme of department store Santas. What are they doing in the woods? A council? A picnic? A trial? The poodle is really Little Betty disguised in a way that will make her acceptable, "no longer banging around," but just as obtuse. Santa, quite the Victorian gentleman, is otherwise some mad, uncontrollable dwarf, all that is unruly in us." He is depicted as the opposite of what he is, a subtlety that would not have been in Roller's repertory a few years ago. The specimen jar in the foreground awaits collection "for analysis by a superior being."

One of Roller's finest paintings, THE MAN HAS LEFT THE MOON TONIGHT (page 81), which is now a part of the permanent collection of the Hirshhorn Museum at the Smithsonian Institution, introduced the "new" character, Gladys Atlas. She is the White sisters in a more sophisticated guise. She is further along the psychic trail than the White sisters: moonstruck, like Pierrot Lunaire. She has left the moon for a dark place in the woods.

To paint this picture Roller used the lamp in the setting as the only illumination in the studio. This way objects are more individually rendered, then united by the dark infusion. Each is set apart, then joined. Gladys smokes Camels in both hands near an actual camel legbone (lent to him by the University of Arkansas museum). "Cf. smoking a Camel and the actual leg." The meat is cut out of the heads of state (skeletons). An ammunition box is filled with cabbage heads, "negative existence in my mind, but not in the painting." The smoking box is evil. Gladys' costume

was lent to Roller by the costume department at the university, "not from my prop room downstairs." The jack-o'-lantern is a development of his preoccupation with melons and also with monitors. "This jack-o'-lantern has been robbed like a tomb, and the robbers went one step further and illuminated the scene of the crime." To see how this image has grown compare its predecessor in SUNDAY SINGER (page 101). The quality of a suspended state of necromancy, the prophetic séance, is more solemnly visited upon us in such late paintings. Because the costumes and accoutrements are quieter, they distract us less. The concentration is not on the getup but on the strange-minded uncanny sense of ritual. A black dress with lace suffices. The lamp burns dimly.

MRS. WHITE HAD PARKED HER CAR (page 79) is an effective sequel to Gladys Atlas, but even more recondite and discreet in presentation of theme and content. "Since there were complaints about Mrs. White's noisiness, I subdued her in the paper bag. She is ordered, hooded like a canary at night, awaiting reincarnation."

Both of these midseventies pictures deal with sections of figures, their "tracings," fragmentations. The program is obscure. The goings-on are transparent. For a moment, without grasping or knowing it, we touch "the other side."

When I visited Roller in Fayetteville in July 1978, to see the new body of work, I found things changed, but only in degree. Something naughty is in the atmosphere of Roller's recent paintings, something ultimately threatening—all the naughtier for being nice, all the more visible for being nonvisible, more prescient for being less overt. Less ancillary information is given us, but there is more mystery and clearer design. In his studio was a vast new picture of two dwarflike masked children—one wearing a George Washington mask. They are like freak dwarfs in a museum of spiritual science instead of material science. Is the ghost of Ensor rattling in Arkansas? Roller hints that "these children are the reincarnation of Cain and Abel." He has them seated behind a campfire made "from limbs saved from the burning

bush which spoke to Moses." One of the children is plump, turgid, and wearing an old lady mask. But what is old and what is young? And when? What process is being investigated; what process is being speeded up here? Regardless, they will always sit in their paradox in a sofa-ed throne room to show that spiritual drift isn't Spinoza or the Virgin Mary, but George Washington's head on a boy's body (see page 19).

Roller's work is saturated with voyeurism. Is someone being judged or fingered? "Observing and being observed, catching and being caught—there isn't much difference between the two. Because in the psychological sense, it is very exciting for both parties, and the activity can be manifest on a level as low as voyeurism or as high as the precious level that occurs when you suspect that God is hearing your prayers."

A painter in Roller's position is forced to become his own voyeur. Increasingly his work conveys the impression of private observance of clandestine events. We really should not be there. But we are lucky to witness the rite. Once embarked upon, there is no way out because psychic projection, not style, is the aim. Does that seem a little old-fashioned right now amid academic fourth generation abstraction in the rather dead late 1970s? On the contrary, it seems refreshing, on target—not everyone's meat but no one's poison. Actually, Roller Wilson's art connects more to the perceptual aspects of technologically oriented events and happenings of the 1960s than to what transpires in painting today. There is an underground element to his art: It is cast in an every-type format. It formulates an environment and is highly staged, like scenes from the zodiac in an old manuscript illumination or visits to some subterranean magic theater. Roller's is the original magic lantern show.

Soon Roller will move from the studio above Atlas Van Lines. No more entering through the loading dock corridor and up the stairs. A new studio is in construction in the old part of town down by the city park, on a narrow corner lot by a little ravine. The studio and guest room front the street, walled in and separated by

a covered walkway from the isolated house hidden behind. One enters through the back, as in a Roller Wilson painting. Everything assures privacy—being away from the art world. It is all very comfortable and gracious; nothing seems eccentric, except for a kind of elusive shield which is unidentifiable, but which may be Roller's guardian angel. Here, he will unravel and paint the titles of his future pictures and find that they will compose a story.

Amid mid-American politesse and absolute propriety, he will continue to paint the drifting of materials that feather the day to day into the past and future. Even the feathering touch has become clearer, more distinctive, assured to the point of lucidity. There will be greater self-containment with which to attack the sacred cow which most of us so desperately believe in—that matter has a beginning, a middle, and an end. "And the sacred cow in all this, habitual eating, breathing, really rears its head when the question of time as a linear phenomenon is questioned." Time is multiple, coming from far away and near, from beside us, behind us, and inside us: Once these things are understood, all levels can go on in a painting. Until these things *are* understood, there will be limited understanding of Roller's work.

In 1978 Roller has reached a technical plateau sought after for years. He has come a long way since those paintings of uncomplicated Kansas women with bonnets, single actors in one-act skits, which drew his work to my attention. He has realized the promise, nostalgia, and probing. For with his stages and rooms he has created types beyond the wildest imagination. Like a writer, he has troubled to develop characters and to discipline their antics away from rambunctious behavior so that they can appear on the mature stage.

He has traveled far enough down the road to have realized the vision of an experience he had at the age of five or six, recalled in a letter to Kathy before they were married. It was a foreshadowing of ecstatic attitudes to come. He remembers: "How and why does one become a Romantic? And when? I was swinging in a tree on a Palestine, Texas, lawn, in my white snug cotton underwear. An elastic band. Lawn important—vast and unbounded by other lawns—opening onto surrounding but less manicured places where cows moved freely: a place where I would sing to make them content not to harm me. I was told that trick would work, but the important thing was this: The green was as a pulse. And I would swing high above it and swoop low in a smear of green and brown earth; my head's blood being kept there. Back and forth—the side view of a transparent crescent. And I was self-liberated from an afternoon nap—my mother was having her's still. A clandestine thing—a secret swing.

"And suddenly I was Terry of Terry and the Pirates and I was flying and the swing was a powerful thing and I landed and visited the Dragon Lady and smoked a rolled-up toilet paper cigar! Out of the swing and hidden in the vast roots of the tree. And a first erection—a frightening thing about which I wanted to know but wouldn't ask."

How many people live sustained enough lives to project a child's upset wonder into mature art? That revealing letter was written in 1968. The event (revelation) took place in 1942 or 1943. The painter's easel swings forth into today. It is all implied there—the smoking cats and innate sexuality, the blending of time, the cows in their landscapes and clandestine rituals. Ten years later when I reopened the envelope containing the letter I felt I had opened a Pandora's box, loosening the smoke of Roller's penultimate vision before the mirrors went black and the forests darkened and Mrs. White would no longer sing.

Ralph T. Coe
Director
William Rockhill Nelson Gallery of Art
and Mary Atkins Museum of Fine
Arts, Kansas City, Missouri

LIST OF ILLUSTRATIONS

THE DREAMS
OF DONALD ROLLER WILSON

Title	THE REINCARNATION OF CAIN AND ABEL (ABLE)

THE SKIN HAS RIPPED;
THE CORE (RELEASED) NOW BURNS UPON THE TABLE:
AN ALTAR OF THE FUTURE, RIMMED WITH ROSES
THE EARTH'S HOT CENTER:
BURNING LIMBS (LEFT OVER FROM THE BUSH):
A SPEAKING TREE HEARD THROUGH THE EAR OF MOSES

THE COW HAS COME,
BEHIND THE POND (A GHOST OUT IN THE FOREST)
BEHIND THE DRAPE, THE ONE WHICH NEVER CLOSES
SHE STRAINS TO SEE
THE CHILDREN THERE (REBORN BEHIND THE BUSH)
DISGUISED BEHIND THEIR ARTIFICIAL NOSES

Medium	Oil on canvas
Size	Height: 60 inches
	Width: 87 inches
Signed	DONALD ROLLER WILSON
	FRIDAY · OCTOBER 6 · ♥
	1978 · 4:33P.M. DAY
	BEFORE JUDEE'S BIRTH ·
	AND NOW TO SHOW THE
	WAITING RABBIT ♥
Collection	Private

18

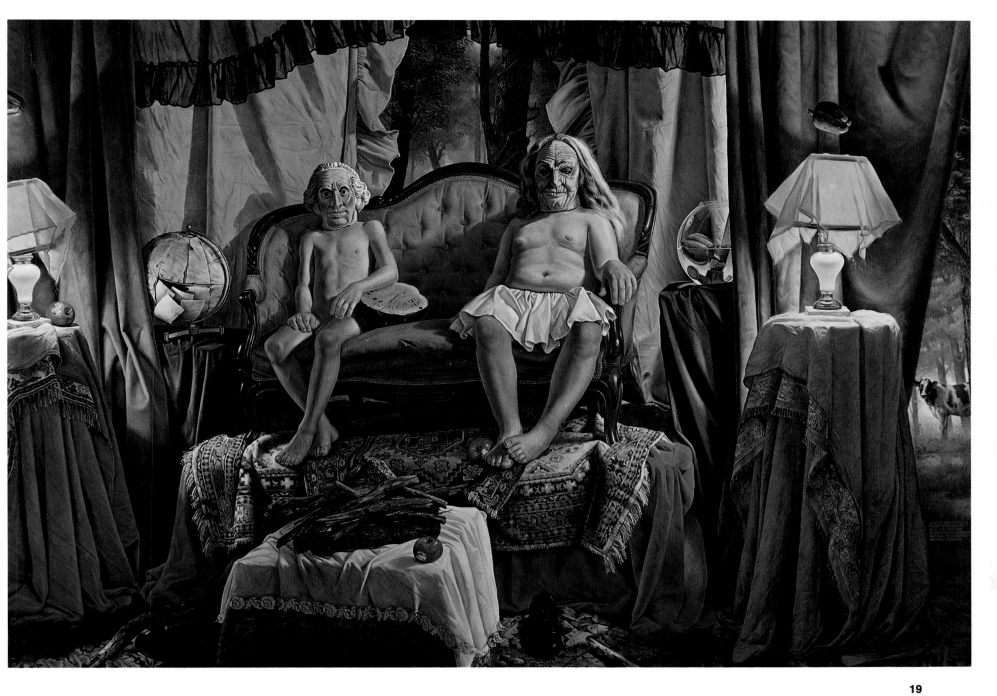

Title	THE RETURN OF SHIRLEY FROM PARADISE

SHIRLEY CAME BACK THROUGH THE GATE;
HER DRESS HAD STAYED THE SAME
SHE LOST HER RAG-DOLL HEAD—BUT GAINED A REAL ONE

HER WET NURSE FOUND HER IN THE BOX
(WHICH USED TO HOLD AN URN)
OF ASHES—FROM THE FIRES (OF HIROSHIMA)

Medium	Oil on canvas
Size	Height: 50 inches Width: 64 inches
Signed	DONALD ROLLER WILSON 3:11P.M. FRIDAY · AUGUST4 · 1978
Collection	Private

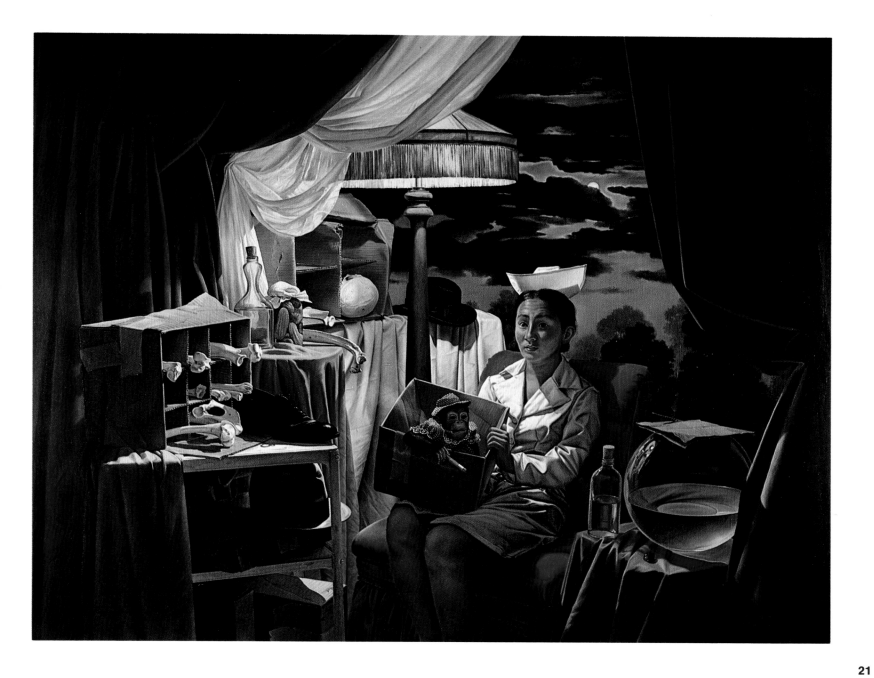

Title	SHIRLEY'S LAST SUPPER PRIOR TO HER RETURN FROM PARADISE

BEFORE HER ENTRANCE THROUGH THE GATE
BETWEEN THE LEGS OF GLADYS
BEFORE THE CALL WHICH CAME—(PLACED BY HER HOST)

SHE PASSED A MAN WHO HAD TWO HEADS
WHO ALSO CAME THROUGH GLADYS
BUT, IN REVERSE—THE SON—(THE HOLY GHOST)

Medium	Oil on canvas
Size	Height: 40 inches Width: 50 inches
Signed	DONALD ROLLER WILSON TUESDAY · JUNE20 · 7:03P.M. 1978 ♥ SHIRLEY'S DINNER
Collection	Private

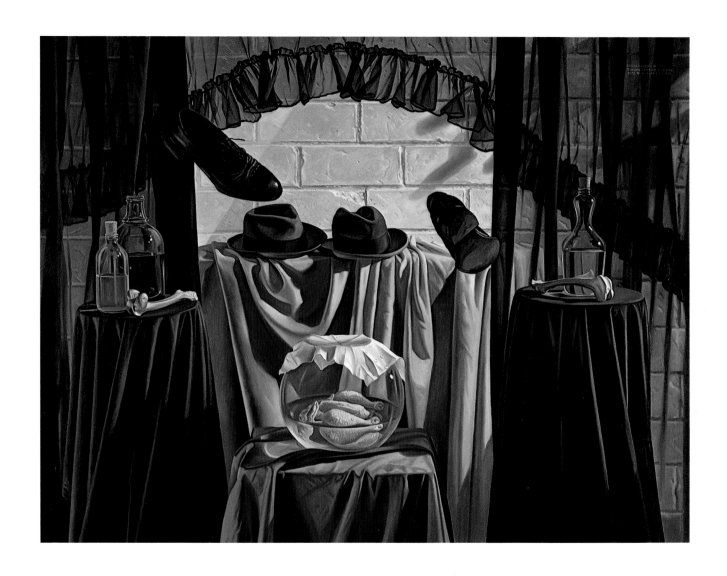

Title	BLUE ROAST: ROLLED RUMP
	THE SHADOW OF THE BONE IS CURVED; IT FALLS ALONG THE FOLDS OF DRAPES WHICH HANG BEHIND THE STEAMING JEANS
Medium	Oil on canvas
Size	Height: 16 inches Width: 20 inches
Signed	DONALD ROLLER WILSON WEDNESDAY · JUNE 6 1978 · 4:27P.M. ♥
Collection	Mr. Douglas Cramer, Los Angeles, California

24

Title	THE DESTRUCTION OF A WHITE HOUSE ON THE PLAINS

THE HEAD OF STATE—HIS HOLLOW BONE,
A WIND HAD SHED HIS SKIN;
A WHIP—A THIN BLACK WHIRLING AIRBORNE CONE

BUT LITTLE COOKIE LEASHED HER GOOSE
TO SAVE IT FROM THE WIND;
THEY WAITED ON THE STEPS BELOW THE THRONE

Medium	Oil on canvas
Size	Height: 75 inches Width: 60 inches
Signed	DONALD ROLLER WILSON SUNDAY · APRIL 30 · 1978 3:18 P.M. ♥ TOTO, I DON'T THINK WE ARE IN KANSAS ANYMORE · · ·
Collection	Mr. Frank Bürgel, Teheran, Iran

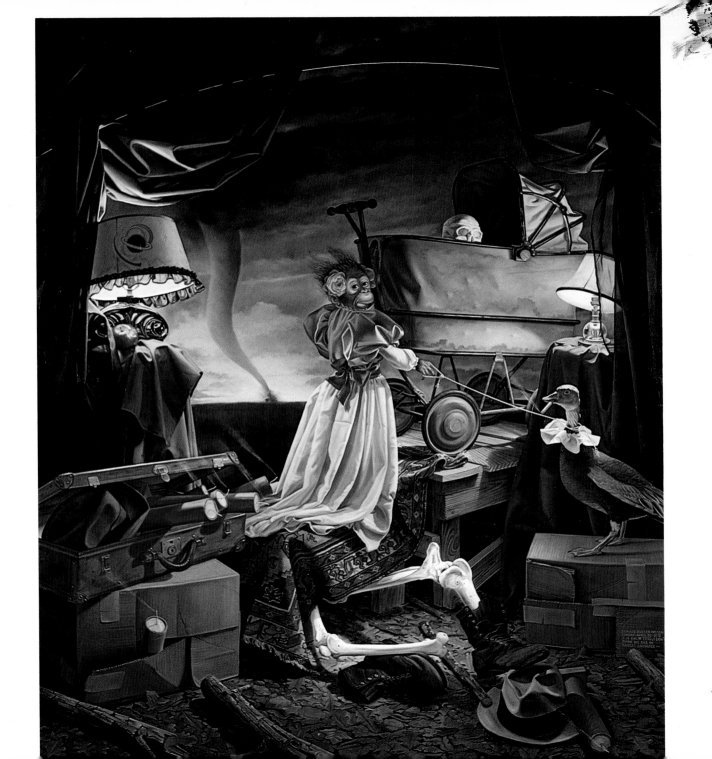

Title	THE CLONE; THE FUSE; AND SISTER DINAH MIGHT

ON YERBA BUENA ISLAND
(WHERE THE GOLDEN GATE <u>HAD</u> BEEN)
BEFORE THE SILVER TUBE HAD LANDED IN THE NIGHT,
OUR HEAD OF STATE WAS HANGING
AS A DRY BONE—GONE TO SEED;
IT HUNG BESIDE THE HEAD OF SISTER DINAH MIGHT

Medium	Oil on canvas
Size	Height: 64 inches Width: 87 inches
Signed	DONALD ROLLER WILSON FRIDAY · MARCH 31 · 1978 · 5:18P.M. THIS BOX HAS NO BRAND NAME ON IT BECAUSE THERE IS NO WAY TO DESCRIBE THE CONTENTS · · · BUT THE DOG NOSE
Collection	Mr. John Berggruen

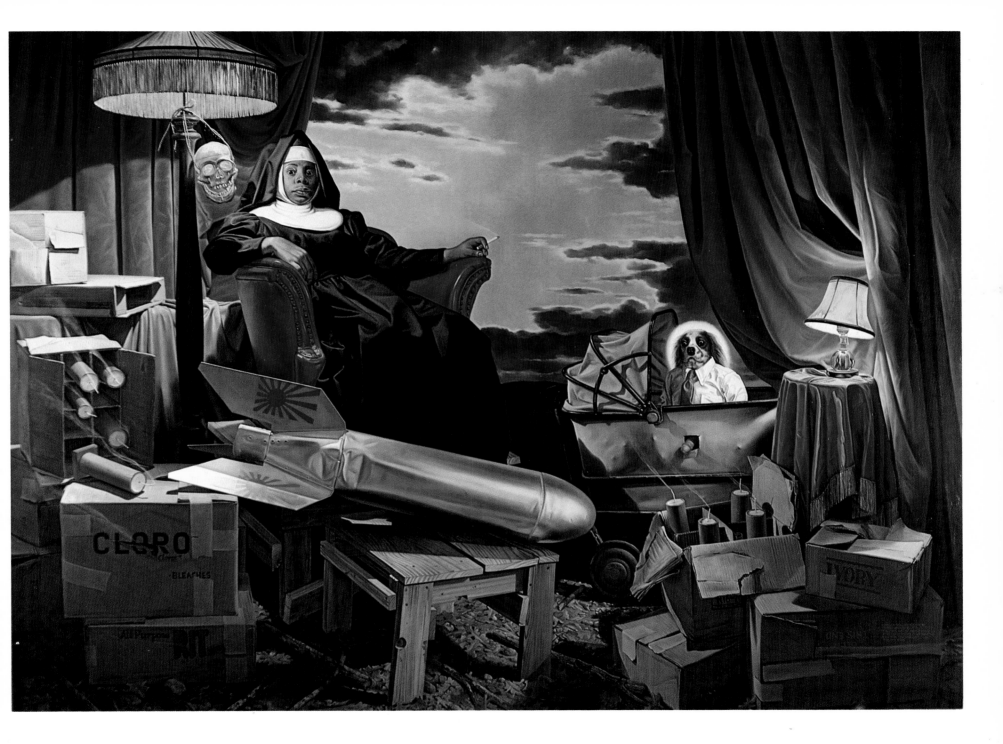

Title	BETTY JANE LONG PAST HER WEDDING; LONG PAST HER SISTER HAZEL
Medium	Oil on canvas
Size	Height: 24 inches Width: 26½ inches
Signed	DONALD ROLLER WILSON TUESDAY · FEBRUARY 14 ♥ 7:37P.M. VALENTINE'S DAY · 1978
Collection	Mr. Seymour Surnow, San Francisco, California

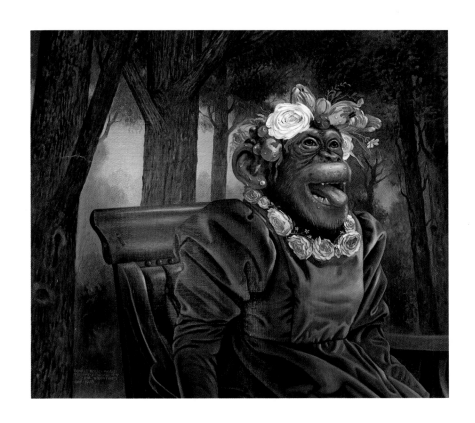

Title	IN THE EVENING—WAITING
	FOR A CALL WHICH SURELY CAME
	AND WAITING FOR THE NEWS WHICH CAME BEFORE THE CALL,
	WE HID OUT AS A WELL-DRESSED DEER
	WHILE BUBBLES IN THE PARK
	BEGAN TO DRIFT
	AND SHRINK
	AND BURST—BEFORE THE FALL

Medium	Oil on canvas
Size	Height: 42 inches
	Width: 48 inches
Signed	DONALD ROLLER WILSON
	FRIDAY · FEBRUARY 10
	6:08P.M. 1978 ♥
Collection	Private

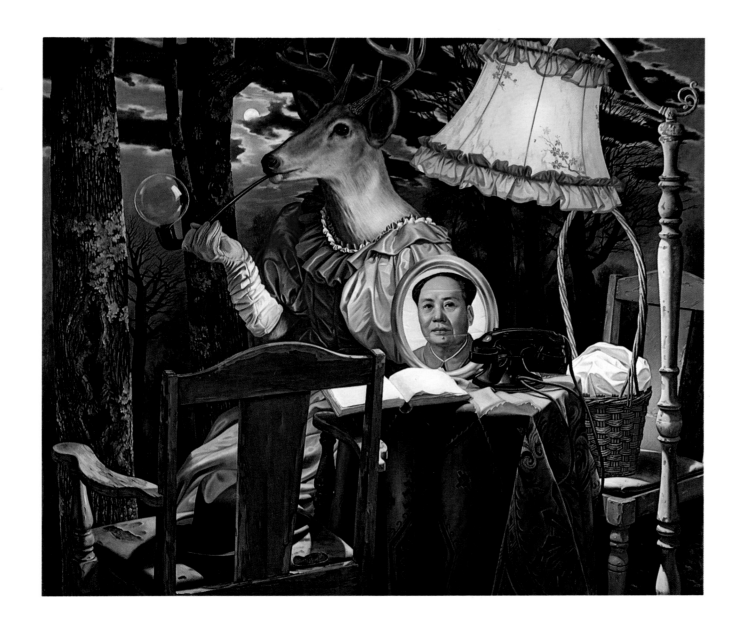

Title	THE HUSBAND OF THE QUEEN WHO CAME; HER SILVER SHIP RETURNING
Medium	Oil on canvas
Size	Height: 30 inches Width: 33 inches
Signed	DONALD ROLLER WILSON EARLY DECEMBER · 1977 ♥
Collection	Private

Title	LITTLE BETTY'S FRIEND IS HERE HE'S GOING TO LICK HER OLIVE; HE'S GOING TO CHEW IT TOO—IT SEEMS TO ME
Medium	Oil on canvas
Size	Height: 14 inches Width: 16 inches
Signed	DONALD ROLLER WILSON FRIDAY · NOVEMBER 11 · 1977 4:01 P.M.
Collection	Mr. and Mrs. Steven Jay Rudy

36

Title	CAME FROM WISHING; ON THE FRONT PORCH ROLLED ROAST TID-BIT ON MY MIND; NOT A GREEN ONE: RED-STUFFED GREEN ONE, WANT A T-BONE—WANT <u>THAT</u> KIND!
Medium	Oil on canvas
Size	Height: 10 inches Width: 14 inches
Signed	DONALD ROLLER WILSON SUNDAY · OCTOBER 30 · 1977 5:24 P.M. ♥
Collection	Mr. Donald Roller Wilson

Title	KATHLEEN
Medium	Oil on panel (masonite oval)
Size	Height: 11 inches Width: 14 inches
Signed	DONALD ROLLER WILSON THURSDAY · SEPTEMBER 15 · 11:27 P.M. ♥ 1977 · KATHLEEN ♥
Collection	Editions, Inc., Houston, Texas

Title	THE HAT THE HEAD OF STATE HAS LEFT
Medium	Oil on canvas
Size	Height: 18 inches Width: 26 inches
Signed	DONALD ROLLER WILSON 7:38P.M. SATURDAY · SEPTEMBER 3 · 1977
Collection	Mr. and Mrs. Weldon Steinman, Jr.

Title	AUNT WHITE HAS PASSED AWAY TODAY, OR YESTERDAY—OR LONGER; HER RUFFLED SLIP IS DRIFTING IN THE SKY
	THE DOCTOR'S HAT AND BAG AND CAT HAVE STAYED—THOUGH HE STILL WANTS THEM; HE'LL CALL US WHEN THE DIAL CAN BE UNTIED
Medium	Oil on canvas
Size	Height: 32 inches Width: 40 inches
Signed	DONALD ROLLER WILSON ♥ 1977 SATURDAY · AUGUST 27 · 5:49 P.M. IF YOU ARE READING THIS—HELLO, HOW IS YOUR PUSSY—DOES IT SMOKE?
Collection	Mr. Robert Marco

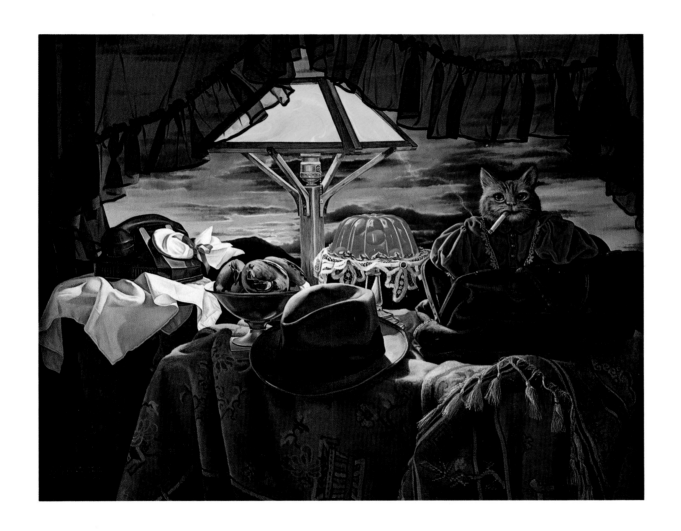

Title	WAITING OUTSIDE OUR HOME BY THE POND

HIS PENCIL MOVED INSIDE OUR EARS
IT MARKED SOME CLEAR DIRECTIONS;
THE DOCTOR CAME, BUT LEFT HIS LEATHER CASE;
DOWN IN THE STICKS AND ROCKS AND LEAVES,
HE CAME IN NEAR PERFECTION—
HIS CRYSTAL BALL IS RESTING ON ITS BASE

AND, THERE'S A GIRL IN BLACK IN MARY'S PLACE

Medium	Oil on canvas
Size	Height: 75 inches Width: 100 inches
Signed	DONALD ROLLER WILSON SUNDAY · AUGUST 21 · 10:29 P.M. 1977 WAITING OUTSIDE OUR HOME BY THE POND
	FOR BOB, MY FRIEND
Collection	Mr. and Mrs. Arthur Goldblum

46

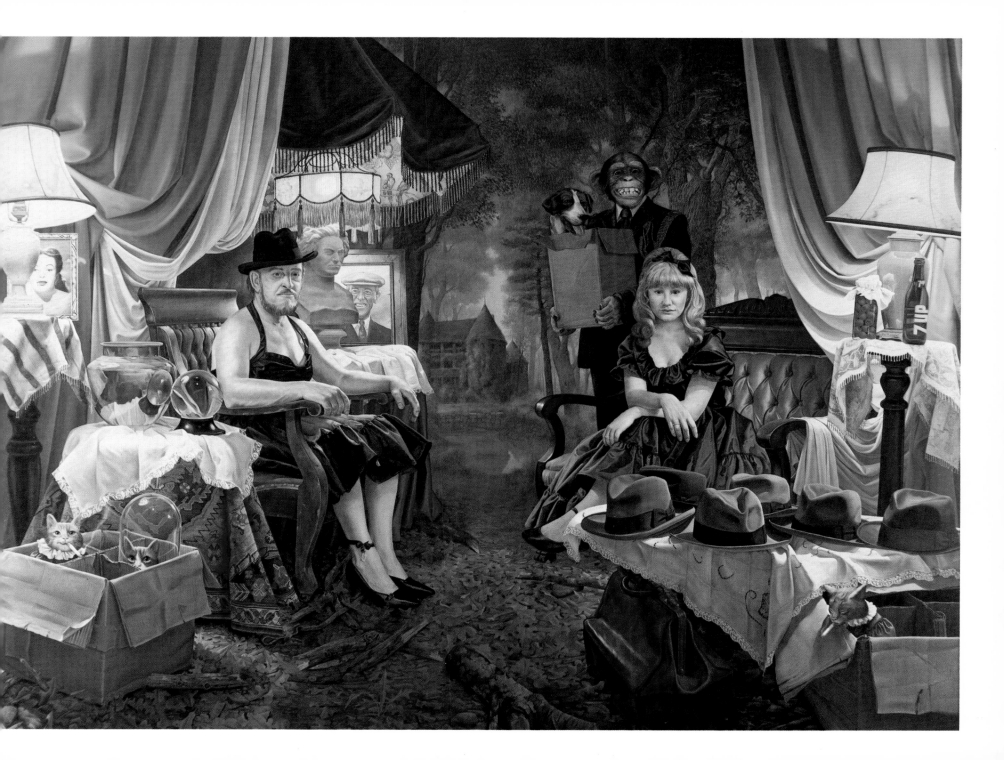

Title	AUNT WHITE SINGING IN THE WOODS: JUST A YOUNG GIRL—(AND HER PUSSY); PUSSY SMOKES AND LOOKS AND LISTENS; DREAMS OF TUNA IN HIS BOX!
Medium	Oil on canvas
Size	Height: 48 inches Width: 48 inches
Signed	DONALD ROLLER WILSON MARCH 6 · SUNDAY · 1977 8:42P.M. FULL MOON
Collection	Mr. and Mrs. Oree A. Bryan

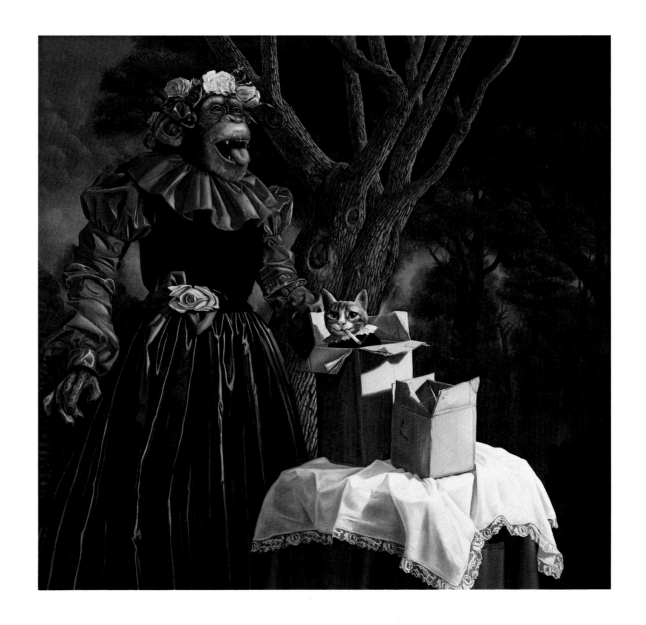

Title	LITTLE LORETTA—MY NEW FRIEND; SMOKES AND MEWS, AND LOOKS—AND THINKS
Medium	Oil on panel (masonite oval)
Size	Height: 8 inches Width: 10 inches
Signed	DONALD ROLLER WILSON LITTLE LORETTA · MY NEW FRIEND EARLY FEBRUARY · 1977
Collection	Mr. Graham Nash

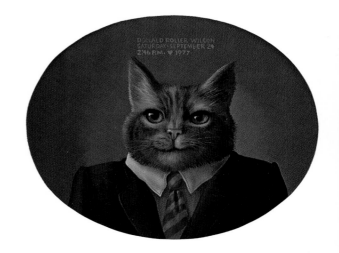

Title	LORETTA'S FATHER
Medium	Oil on panel (masonite oval)
Size	Height: 8 inches Width: 10 inches
Signed	DONALD ROLLER WILSON SATURDAY · SEPTEMBER 24 2:46P.M. ♥ 1977
Collection	Mr. Wayne B. Duddlesten

Title	LORETTA'S UNCLE—METHODIST MINISTER
Medium	Oil on panel (masonite)
Size	Height: 9½ inches Width: 14 inches
Signed	DONALD ROLLER WILSON TUESDAY · OCTOBER 11 · 1977 6:35 P.M. ♥ LORETTA'S UNCLE, METHODIST MINISTER ·
Collection	Mr. and Mrs. Isaac Arnold, Jr.

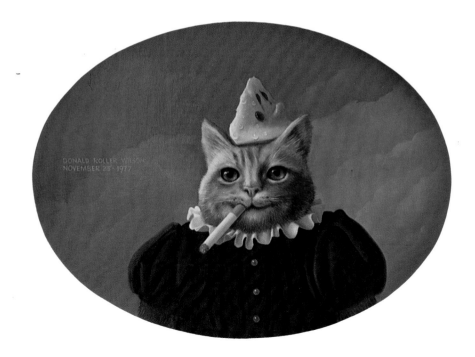

Title	LORETTA'S SISTER PUFFS AND SMOKES; WEARS A MELON ON HER HEAD
Medium	Oil on panel (masonite oval)
Size	Height: 11 inches Width: 14 inches
Signed	DONALD ROLLER WILSON NOVEMBER 23 · 1977
Collection	Dr. and Mrs. R. G. McCandless

Title	THE LAST ZEPPELIN DESTROYED IN THE WAR, AT FRIEDRICHSHAFEN

THE HEAD OF STATE HAS LEFT HIS HAT;
A QUEEN HAS COME TO RULE;
HER SILVER SHIP RETURNING TO THE MOON

SHE BROUGHT A DRINK A COW ONCE SIPPED
WHEN TRICKED INSIDE A ROOM;
HER HOLLOW SHIP IS SILVER—LINED WITH TOMBS

Medium	Oil on Canvas
Size	Height: 87 inches Width: 60 inches
Signed	DONALD ROLLER WILSON · WEDNESDAY · DECEMBER 22 · 1976 · 3:01 P.M. AND THE RABBIT FOUND HARDWOOD UNDER THE KITCHEN FLOOR AT 403 WEST SPRING STREET · WHAT HAVE YOU FOUND?
Collection	Mr. Frank Bürgel, Teheran, Iran

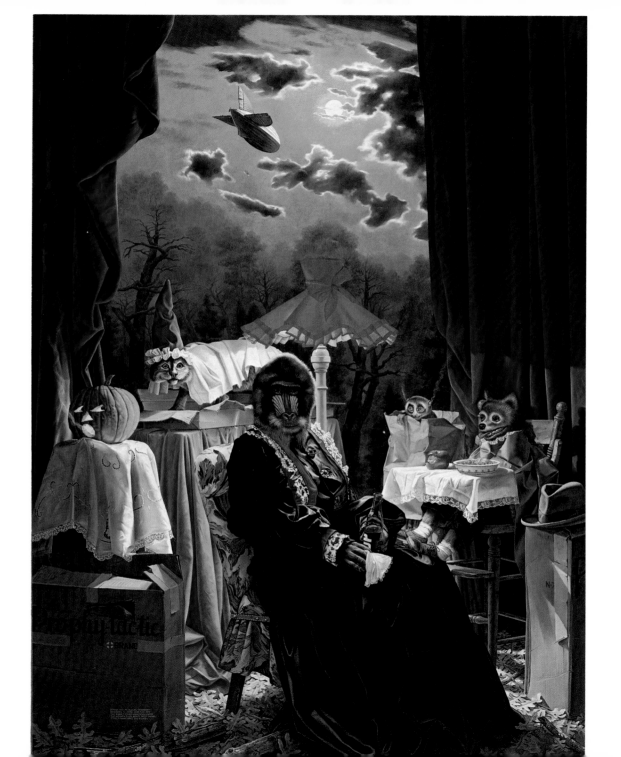

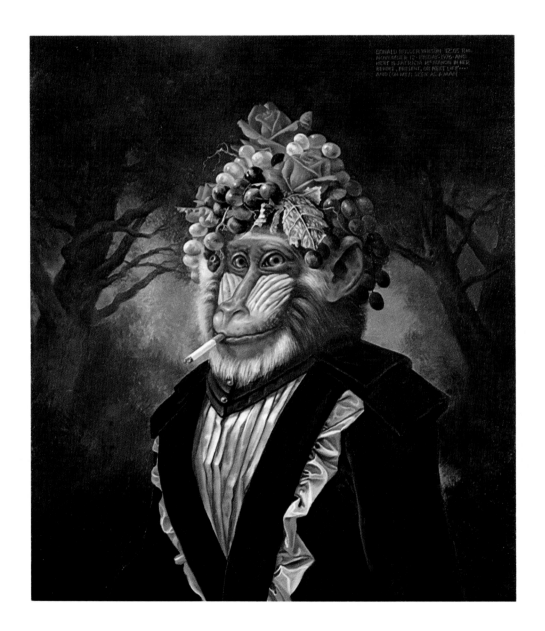

Title AND HERE IS PATRICIA McMAHON
(IN HER BEFORE—PRESENT—OR NEXT LIFE)
AND, (OH MY!)—SEEN AS A MAN

Medium Oil on canvas

Size Height: 24 inches
Width: 20 inches

Signed DONALD ROLLER WILSON 12:05 P.M.
NOVEMBER 12 · FRIDAY · 1976 · AND
HERE IS PATRICIA McMAHON IN HER
BEFORE, PRESENT, OR NEXT LIFE. . . .
AND (OH MY!) SEEN AS A MAN

Collection Mr. Stuart Tray

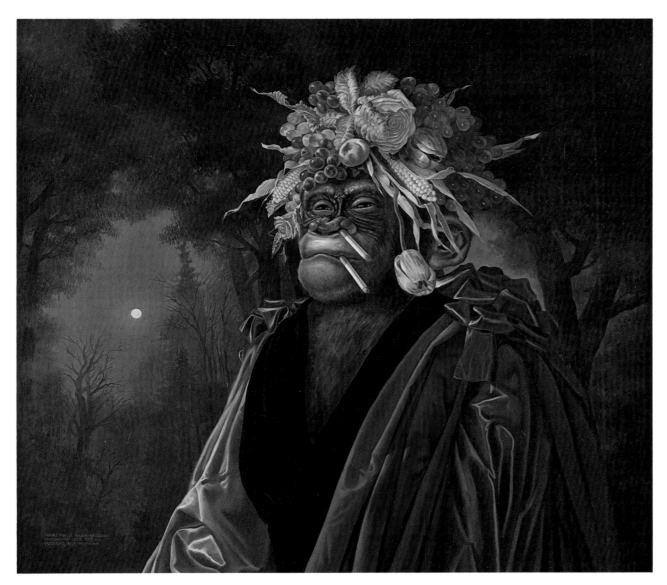

Title	MR. WHITE OUT IN THESE WOODS; WEARING PATRICIA'S NEW WINTER HAT
Medium	Oil on canvas
Size	Height: 30 inches Width: 33 inches
Signed	DONALD ROLLER WILSON • SATURDAY • FEBRUARY 19 • 1977 • 7:03 P.M. PATRICIA'S NEW WINTER HAT
Collection	Mrs. Dennis J. McMahon

Title	AND LITTLE COOKIE LICKED HER LIPS AND LINCOLN'S CHIN WAS CLEAN HIS PANTS—(BOTH PAIRS)—WERE STEAMING AT THE SEAMS A WITCH'S BONEY TOES HAD SPREAD ALL WHITE—AND HARD, AND LEAN; ONE LEG ALONE: HER BROOM HAD BEEN BETWEEN
Medium	Oil on canvas
Size	Height: 40 inches Width: 32 inches
Signed	DONALD ROLLER WILSON SEPTEMBER 7 · 1976 · 2:20 P.M. FULL MOON
Collection	Dr. and Mrs. J. H. Sherman

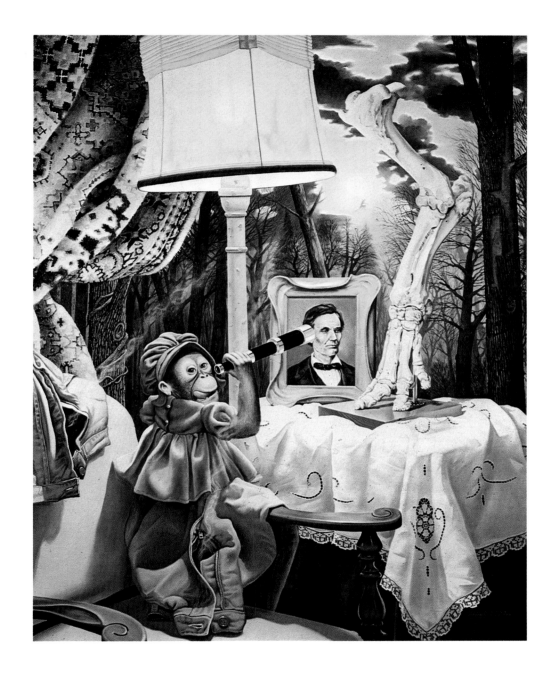

Title	AND HERE IS THE QUEEN: A ROSE FROM MY GARDEN
	STEAMING A PRIME CUT: A NICE LEG OF LAMB
	WHILE UP FROM HIS FRESH GRAVE HER BOBCAT IS HISSING;
	(HEAD OF A CARPET)—HIS HEAD IN THE SAND
	BUT COOKIE SEES CLOSE-UP; A UNICORN DINING;
	WEARING HIS HORN: AN ADJUSTABLE BAND
	THOUGH THE REAL HEAD IS SLEEPING, BONE-HARD AND DREAMING,
	HIS HEAD HAD A REAL HORN—(A HEAD OF THE LAND)

Medium Oil on canvas

Size Height: 72 inches
Width: 87 inches

Signed DONALD ROLLER WILSON
SUNDAY · AUGUST 8 · 1976 · 3:32 P.M.
FULL MOON · STRAWBERRY VISION ·
IF YOU ARE READING THIS RIGHT NOW,
WELL, SO AM I . . . I GUESS THAT MEANS
WE ARE READING AT THE SAME TIME ·
WHAT'S YOUR NAME?

Collection Mr. Mac Harper

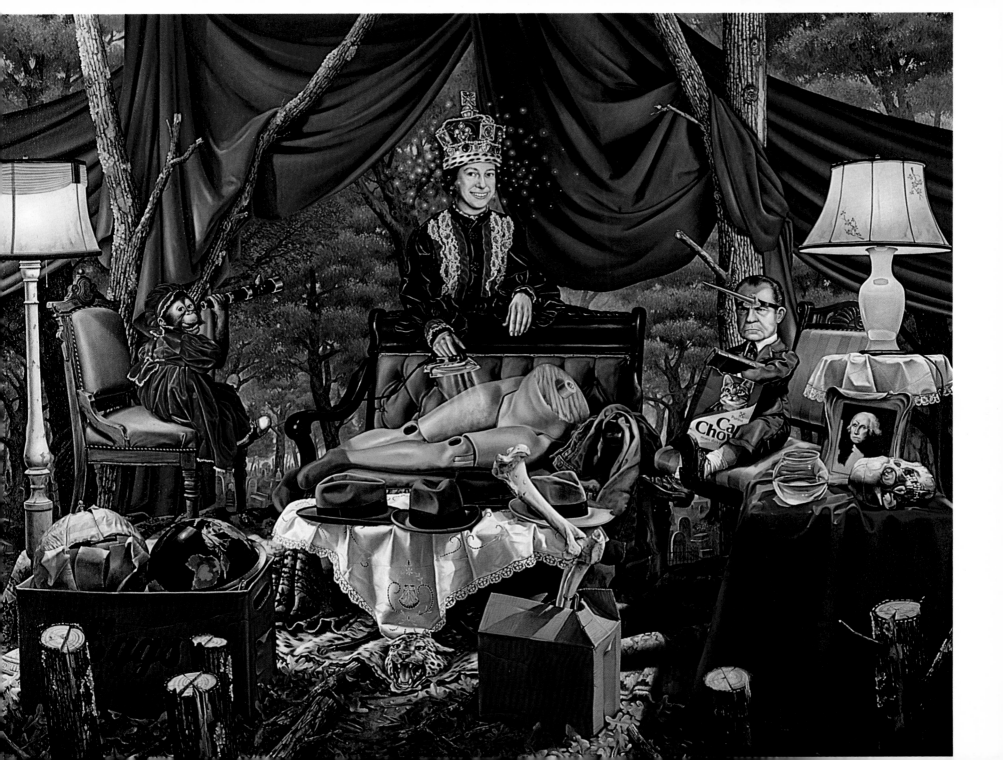

Title	THE ROAST IS RESTING; ROLLED AND FRESH THOSE STEAMING KNEES ARE WOOD THEY SIT BESIDE SOME GREEN ONES—(STEAMLESS, STILL) WE'VE PLANTED BULBS IN LAMPS TONIGHT IN GARDENS IN THE WOODS THEY LIGHT OUR WORLDS, OUR GREEN ONES—(SEAMLESS, STILL)
Medium	Oil on canvas
Size	Height: 72 inches Width: 84 inches
Signed	DONALD ROLLER WILSON SUNDAY · MARCH 28 · 1976 7:46 P.M. NOW TO SHOW THE RABBIT WHO HAS WAITED
Collection	Mrs. Betty Moody

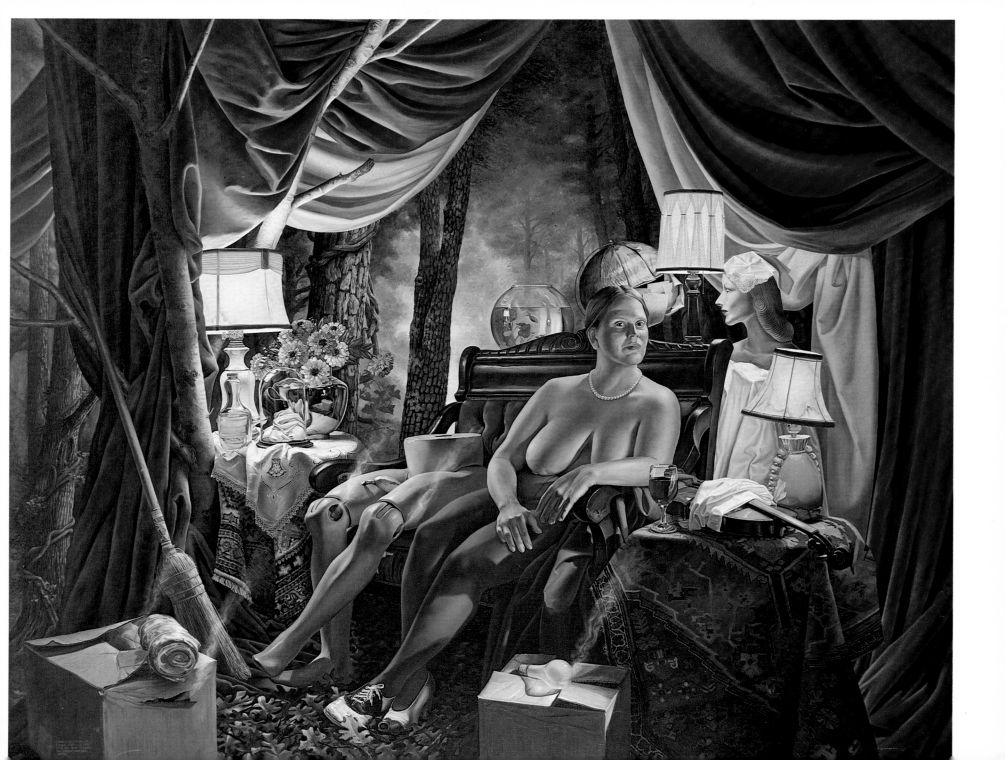

Title	THE ENTRANCE OF SHIRLEY INTO PARADISE

THE BAG OF GROCERIES ON THE CHAIR <u>DID</u> SPOIL AND DRIFT AWAY;
DRIFTED TO A PLACE WE CANNOT SEE
THE PARTS MOVED FASTER AS THEY LEFT AND SPREAD INTO A MIST;
SPREAD INTO A PLACE WHERE <u>WE</u> WILL BE
AND WITH THOSE PARTS RESU<u>MM</u>ONED BY A CALL <u>HE</u> SURELY PLACED,
(CALLED FROM RESTING TO BE BORN ONCE MORE)
THE FORM OF SHIRLEY—DRESSED THE SAME—BEGAN TO MOVE IN SPACE;
ALONG WITH PEPPERS, TOWARD AN OPEN DOOR

Medium	Oil on canvas
	Height: 50 inches Width: 64 inches
Signed	DONALD ROLLER WILSON · SATURDAY · OCTOBER 25 · 1975 · THE ENTRANCE OF SHIRLEY INTO PARADISE · MRS. WHITE HAS REMOVED THE TREES AND THE HILLS AND, HOPEFULLY, THE CRUMBS FROM THE CARPETS OF HOME · 2:38P.M.
Collection	Mr. and Mrs. Michael T. Judd

62

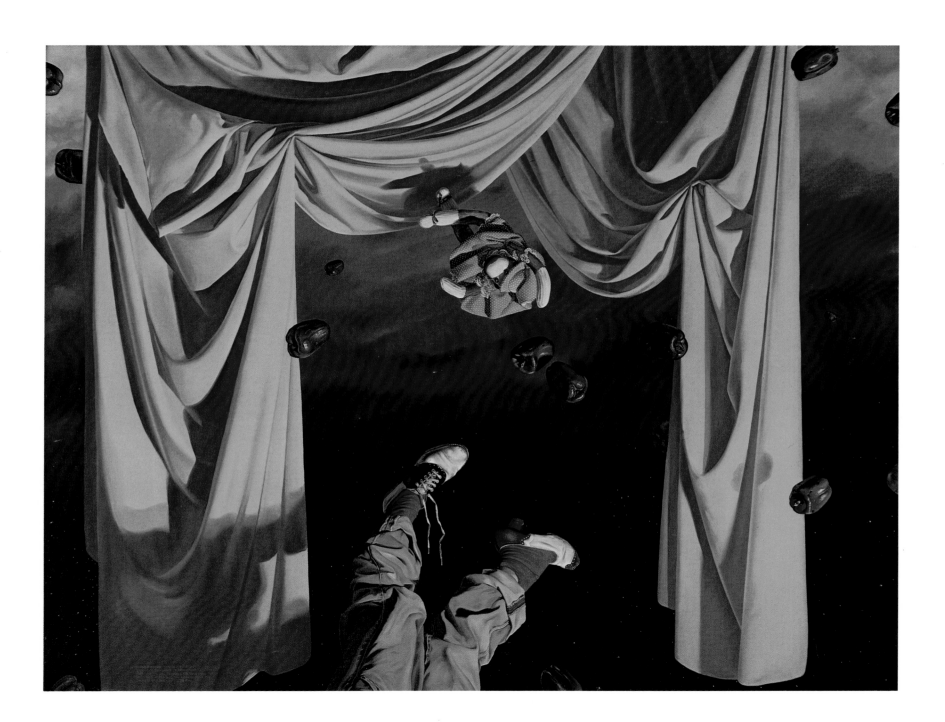

Title	GLADYS WORE HER HUSBAND'S PANTS
	SHE WORE THEM TO THE STORE
	SHE CAME HOME—TIRED—AND RESTED ON THE TABLE
	SHE LEFT HER GROCERIES IN THE BAG
	AND HOPED THEY WOULDN'T SPOIL,
	WHILE SHIRLEY PUT AWAY WHAT SHE WAS ABLE

Medium	Oil on canvas
Size	Height: 41 inches
	Width: 41 inches
Signed	DONALD ROLLER WILSON
	WEDNESDAY · AUGUST 6 · 4:22 P.M.
	1975 · OH, THAT SHIRLEY!
Collection	Mr. and Mrs. Allen Rosenzweig

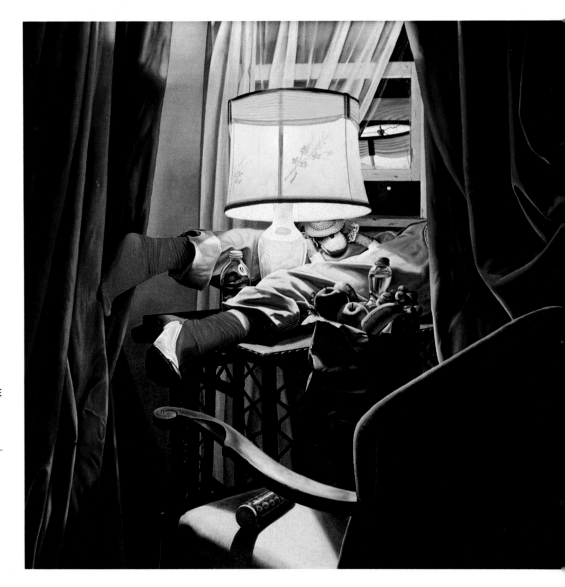

Title IN THE EVENING—LATER—ON THE DAY THAT GLADYS RESTED;
(ON THE DAY SHE LEFT HER GROCERIES ON THE CHAIR)
SHE FELL ASLEEP UPON THE TABLE AND HER SPIRIT LIFTED SLOWLY
AND THAT SHIRLEY WATCHED IT SMOKING IN THE AIR

Medium Oil on canvas

Size Height: 41 inches
Width: 41 inches

Signed DONALD ROLLER WILSON
SATURDAY · SEPTEMBER 20 · 1975 ·
FULL MOON · 12:57 P.M. DAY
AFTER MICHAEL'S BIRTHDAY ·
NAUGHTY SHIRLEY!

Collection Mr. and Mrs. William Key Wilde

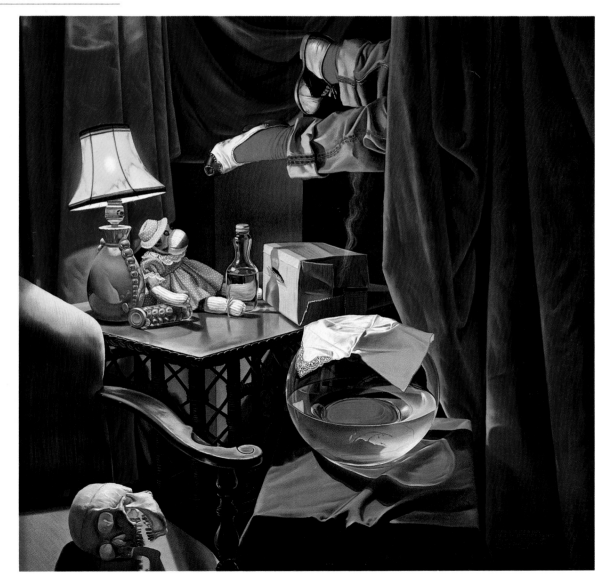

Title	IN THE EVENING OF THAT DAY (AND ON THE TABLE IN THE PARK) WHERE SANTA AND THE POODLE DINED WITH WHITE THE SPIRIT OF THEIR MEETING LINGERED—DRAPED, (AND WITH A HAM) AND RINGS OF SATURN FLEW AROUND HIS HEAD AT NIGHT
Medium	Oil on canvas
Size	Height: 58 inches Width: 50 inches
Signed	DONALD ROLLER WILSON MONDAY · SEPTEMBER 8 · 1975 · 1:01 P.M. A BOX OF PARTS FOR MRS. WHITE'S CAR
Collection	Mr. and Mrs. William Friedkin

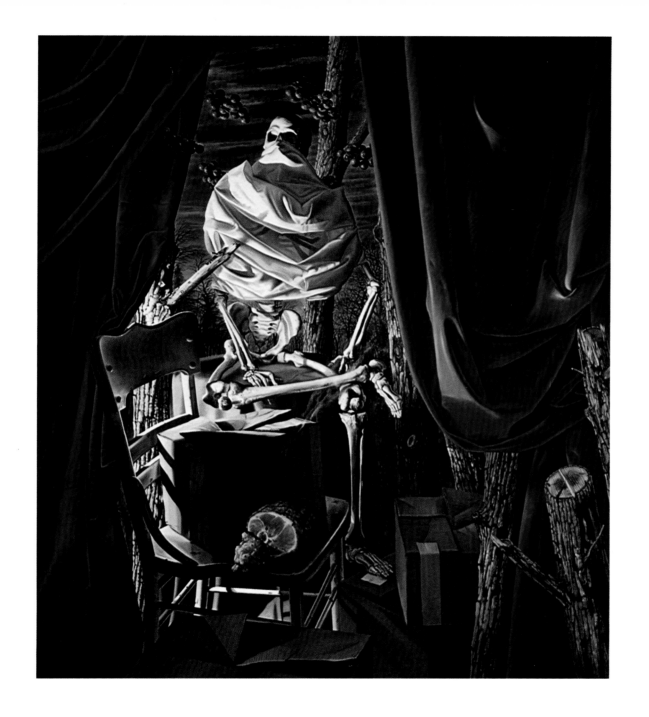

Title	SHIRLEY WATCHES AS SOME RIDERS
	RIDE IN ON A ROLLER SKATE;
	SOME MAY THINK THEY COME FROM STORES
	BUT SHIRLEY KNOWS ABOUT THE GATE
Medium	Oil on canvas
Size	Height: 24 inches
	Width: 26 inches
Signed	DONALD ROLLER WILSON
Collection	Mr. and Mrs. George W. Gilman

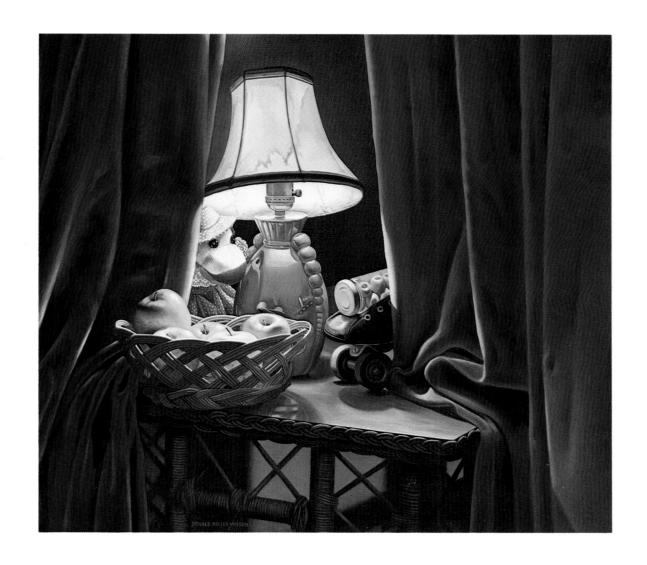

Title	GOING; COMING—THROUGH A WINDOW GLADYS ATLAS IN MY ROOM TENSE TO SEE THE FACE OUTSIDE BUT GLAD TO BE HOME FROM THE TOMB BROUGHT A BASKET FILLED IN HEAVEN FILLED WITH FRANKS; SOME DONE—(SOME NOT) SHIRLEY WANTS VIENNA SAUSAGE GLADYS WANTS A KING-SIZED HOT
Medium	Oil on canvas
Size	Height: 64 inches Width: 50 inches
Signed	DONALD ROLLER WILSON SUNDAY · JULY 20 · 5:34P.M. AND BRUCE AND JUDEE HAVE GONE AWAY · I WILL CALL FOR MY RABBIT TO COME AND SEE
Collection	Private

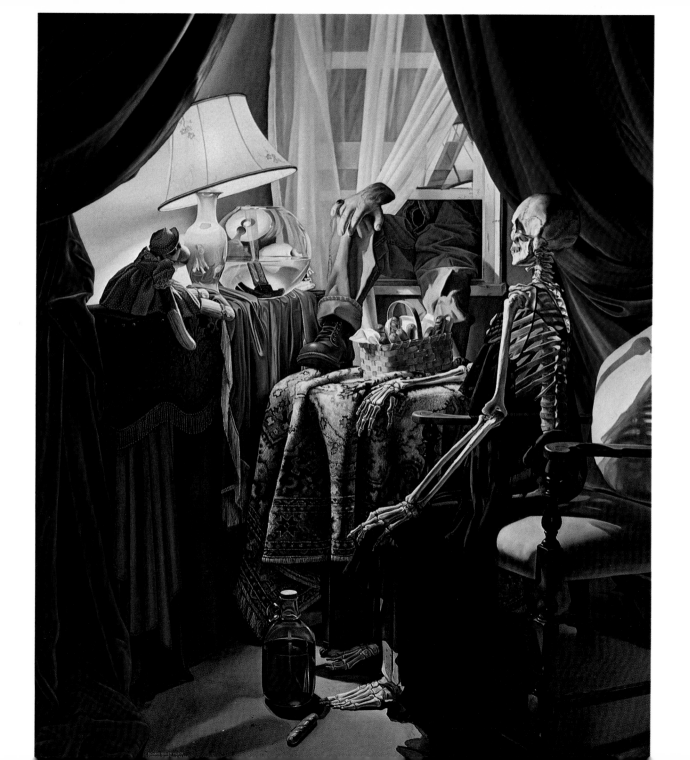

Title	CORI AND RETT HAVE CROSSED A BRIDGE AN ANGEL WATCHED ABOVE THE GARDEN BIRD HAS COME ALL HARD AND RED A MAN OF WAR IS IN HIS PLACE (PUT OUT THE FIRE OF LOVE) MY GARDEN HOSE IS WAITING—IN YOUR BED
Medium	Oil on canvas
Size	Height: 51 inches Width: 64 inches
Signed	DONALD ROLLER WILSON MAY 24 WITH FINAL ADDITIONS COMPLETED WEDNESDAY · JUNE 18 · 8 :29 P.M. · 1975. A STRANGE TASK DONE ALONE · SEEMINGLY
Collection	Jemison Investment Company, Birmingham, Alabama

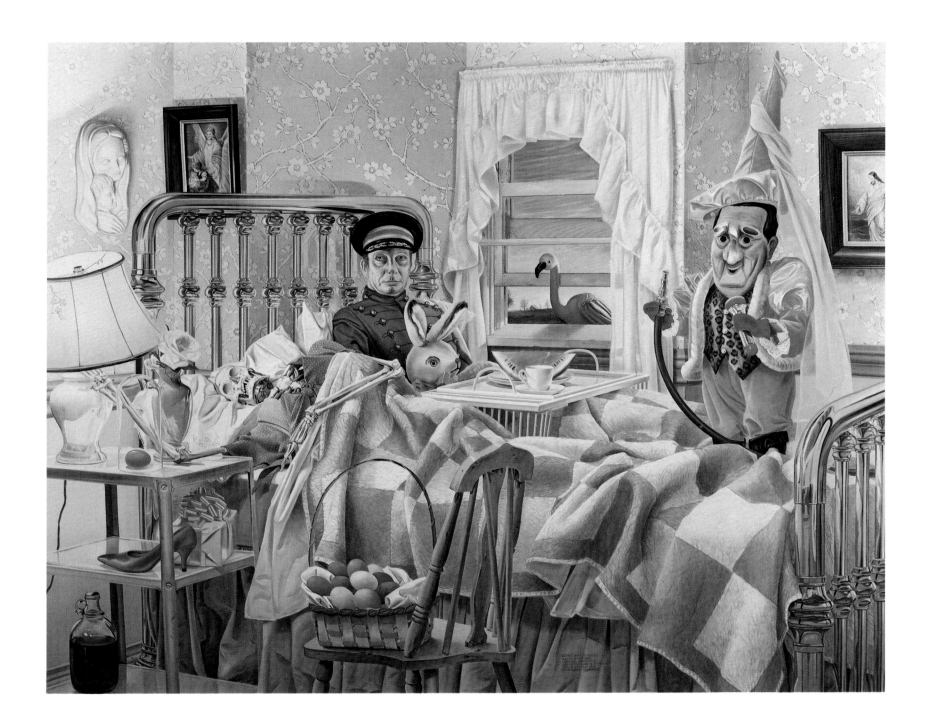

Title	THE DOG BY THE LAKE ON THE WALL OF MY ROOM HAS NO THOUGHTS OF A HIGH HEELED SHOE WHICH COMES UP FROM BEHIND ON THE FOOT OF A GHOST WHO WAS PIERCED BY A FRUIT—(SOME WOULD FEAR) BUT I LOOK THROUGH EYES OF THE FACE OF A LION AND THE DEER LOOKS THROUGH EYES OF A DEER WHILE BARBARA LOOKS INTO A ROOM OUT IN FRONT AND WAITS FOR HER SOUL TO APPEAR WHILE SHIRLEY LOOKS INTO A BELL GLASS JAR AND WAITS FOR HER SOUL TO APPEAR
Medium	Oil on canvas
Size	Height: 50 inches Width: 64 inches
Signed	DONALD ROLLER WILSON SATURDAY · APRIL 5 · 6:20P.M. 1975 FOR KATHLEEN · BARBARA WALTERS WAS COMPLETED JUNE 19 · 1:30P.M. 1975 · AT LEAST ON THIS SURFACE · ON ANOTHER OCCASION IT WAS EARLY LIBRA
Collection	Mr. Frank Bürgel, Teheran, Iran

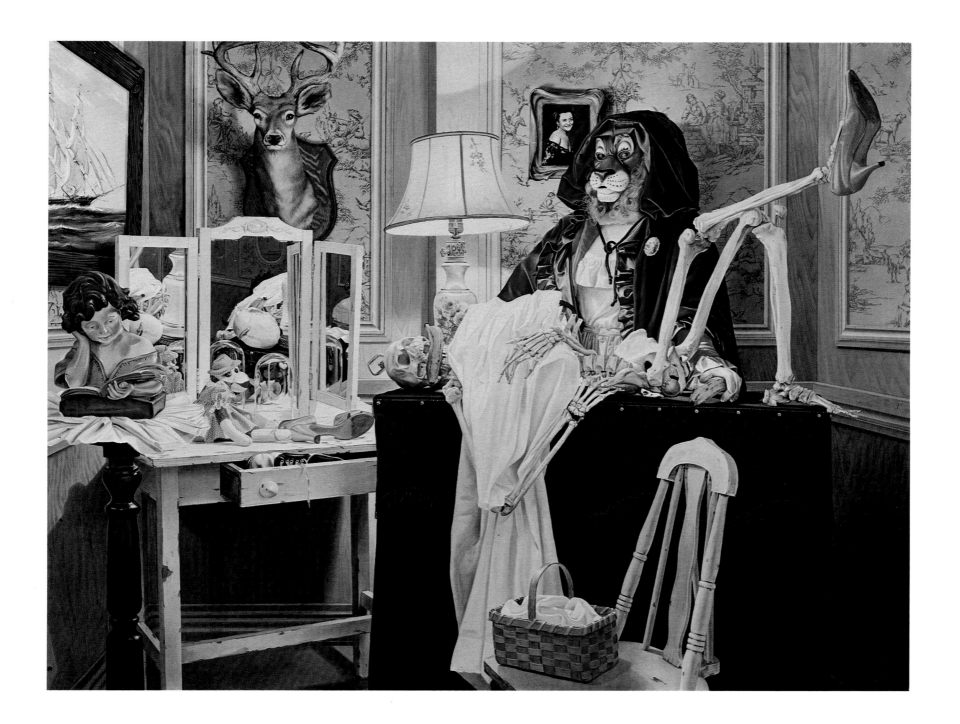

Title	A SMOKING FOX HAS COME TO VIEW THE HOT DOGS AND THE HEAD: A MASK WHICH STAYS INSIDE MY MAKEUP DRAWER
Medium	Oil on canvas
Size	Height: 20 inches Width: 24 inches
Signed	DONALD ROLLER WILSON FEBRUARY 6 · 1975 · 7:15 P.M.
Collection	Mr. and Mrs. James H. Berry

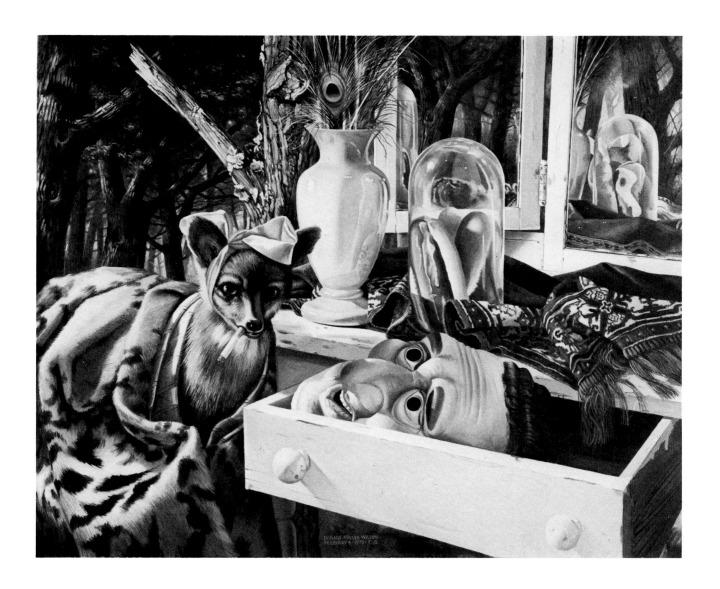

Title	MRS. WHITE HAD PARKED HER CAR AND LEFT THE BEAMS ON HIGH SHE TRAINED THEM ON A TABLE IN THE PARK SHE WRAPPED HER HEAD WITH PAPER BAGS AND MOVED HER EYES INSIDE AND WONDERED WHO HAD JOINED HER IN THE DARK
Medium	Oil on canvas
Size	Height: 50 inches Width: 58 inches
Signed	DONALD ROLLER WILSON JANUARY 14 · 1975 · 4:42 P.M.
Collection	Mr. and Mrs. Leverett S. Miller

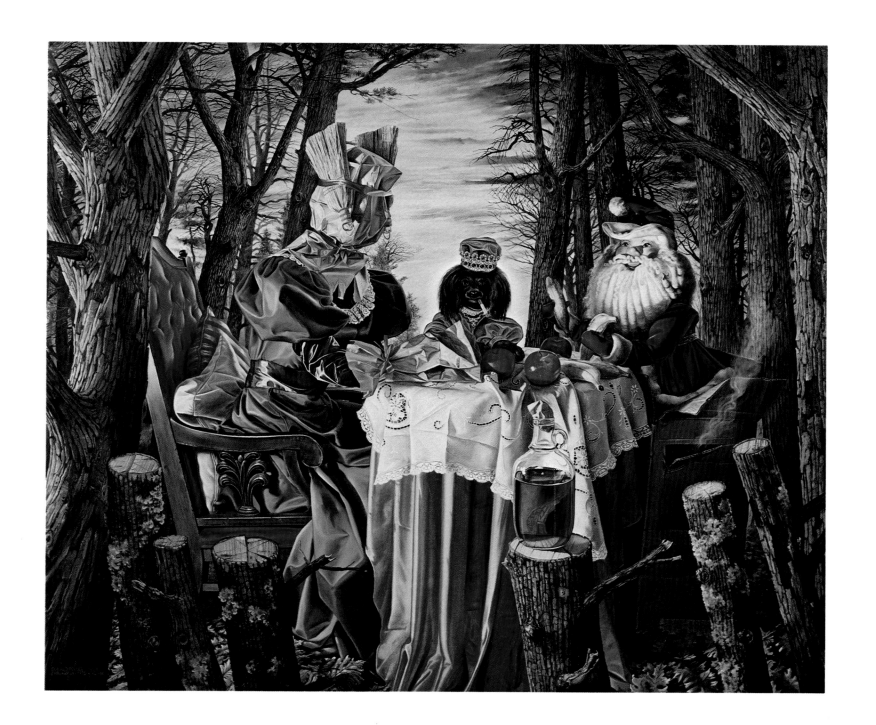

Title	THE MAN HAS LEFT THE MOON TONIGHT HE TRAINS SOME BEAMS UPON THE FACE OF GLADYS ATLAS IN THESE WOODS; HEADS OF CABBAGE—(HEADS OF STATE)
Medium	Oil on canvas
Size	Height: 57⅜ inches Width: 69 inches
Signed	DONALD ROLLER WILSON NOVEMBER 27 · 1974 · SAGGITARIUS DAY BEFORE THANKSGIVING, WHICH IS DAILY FOR HEARTS AS OPENED DOORS
Collection	Hirshhorn Museum and Sculpture Garden, Smithsonian Institution, Washington, D.C.

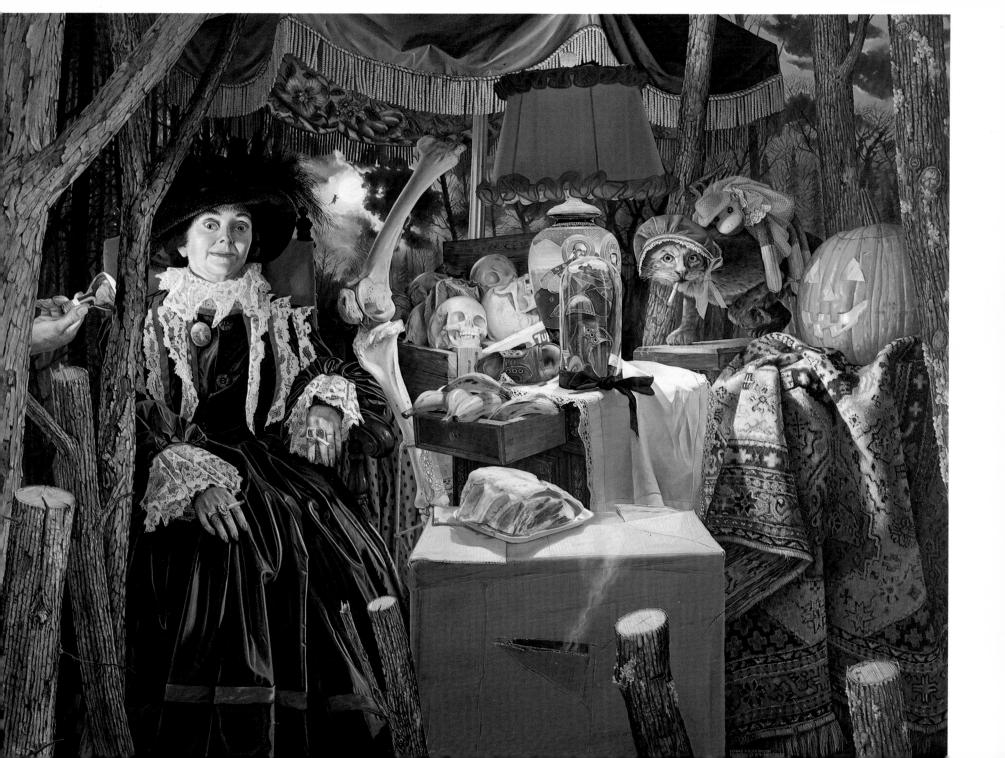

Title	IN MY DREAMS SWEET PAPER PIG THOSE SNOUT STREAMS SMOKING FILL THE AIR WHILE SHIRLEY FISHES FOR A PEPPER; GREEN CHEESE MOON; SHE KNOWS IT'S THERE
Medium	Oil on canvas
Size	Height: 38 inches Width: 44¼ inches
Signed	DONALD ROLLER WILSON TUESDAY · OCTOBER 8 · 1974 LIBRA · PRAISE GOD
Collection	Mr. Arman Fernandez

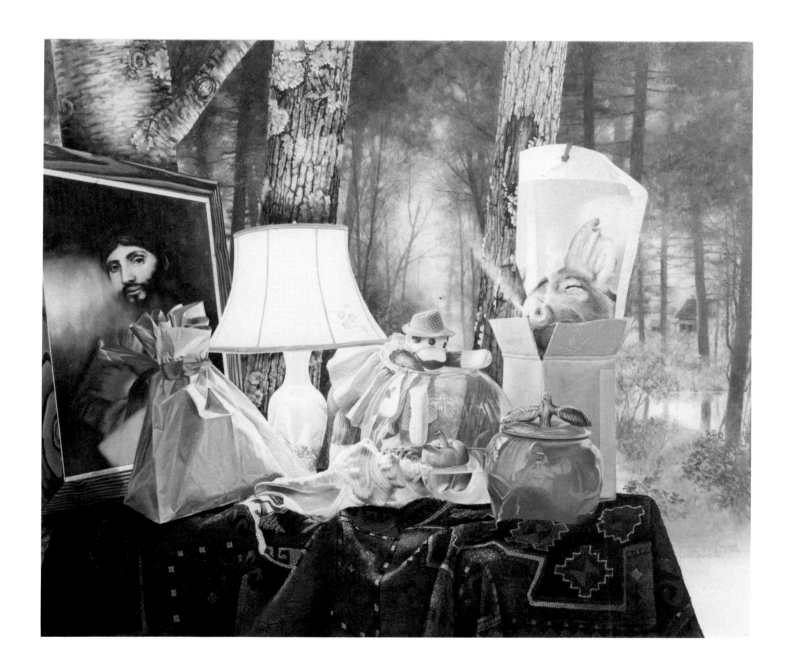

Title	THE BARONESS STARSTRUCK di SUPERNOVA WITH THE BARON'S STAR STUD IN HER EAR SINGS TO A PASSING DILL PICKLE AND HOPES FOR ITS COURSE TO COME NEAR
Medium	Oil on canvas
Size	Height: 44 inches Width: 41 inches
Signed	DONALD ROLLER WILSON SUNDAY · MAY 12 · 1974 · TAURUS
Collection	BARON AND BARONESS ENRICO diPORTANOVA, ROME, ITALY

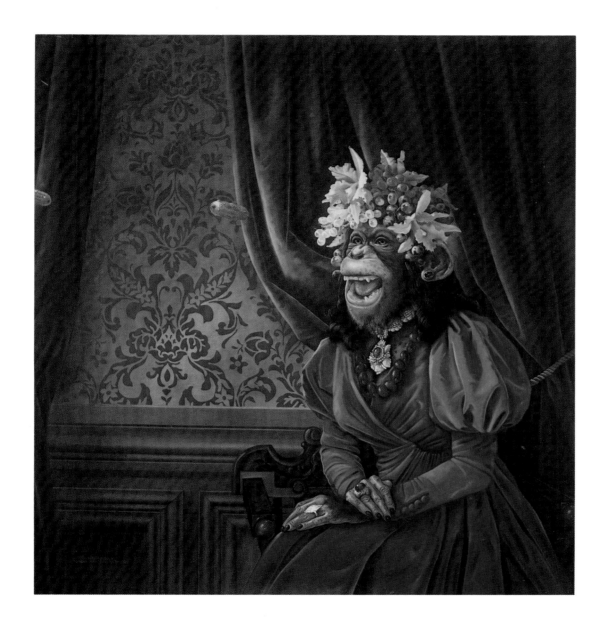

Title	MY MOTHER SAILED IT THROUGH THE WOODS; IT FLOATS AND GLOWS ABOVE HER IRON ; WHICH STEAMED A FOG AS THOSE KINDS DO; AND STRAIGHTENED OUT A FOLDED MIND
Medium	Oil on canvas
Size	Height: 27 inches Width: 30 inches
Signed	DONALD ROLLER WILSON FEBRUARY 23 · 1974 · PISCES
Collection	Mr. and Mrs. Michael Judd

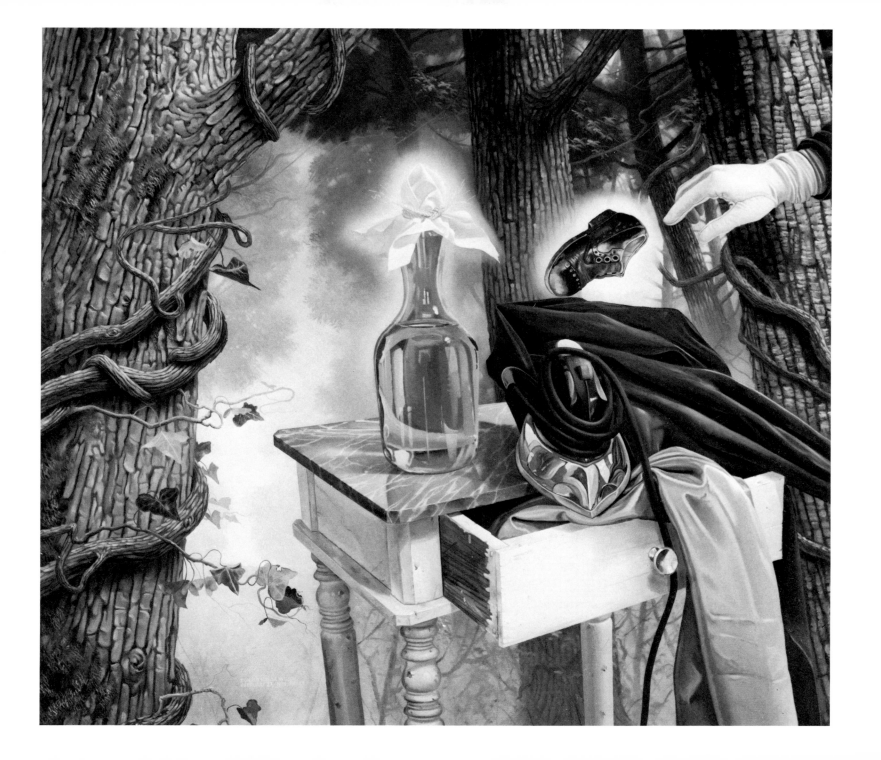

Title	LITTLE SHIRLEY WARMS HER SHOULDER ON THE TEAPOT; STEAMING STEAM; CHIGGER SMILES AND SIPS THAT SEVEN—MOPS HER BROW WHILE (IN BETWEEN), BOSSY LEAVES FROM ALL DAY WAITING—FOR A TASTE OF THAT CLEAR BREW; BETTY CALLS THROUGH OUTSIDE SPEAKERS—BOSSY COME BACK— THERE'S SOME FOR YOU
Medium	Oil on canvas
Size	Height: 60 inches Width: 66 inches
Signed	DONALD ROLLER WILSON FEBRUARY 8 · 1974 · AQUARIUS 3:00P.M. ♥ FOR YOU WHERE YOU ARE
Collection	Mr. and Mrs. Michael T. Judd

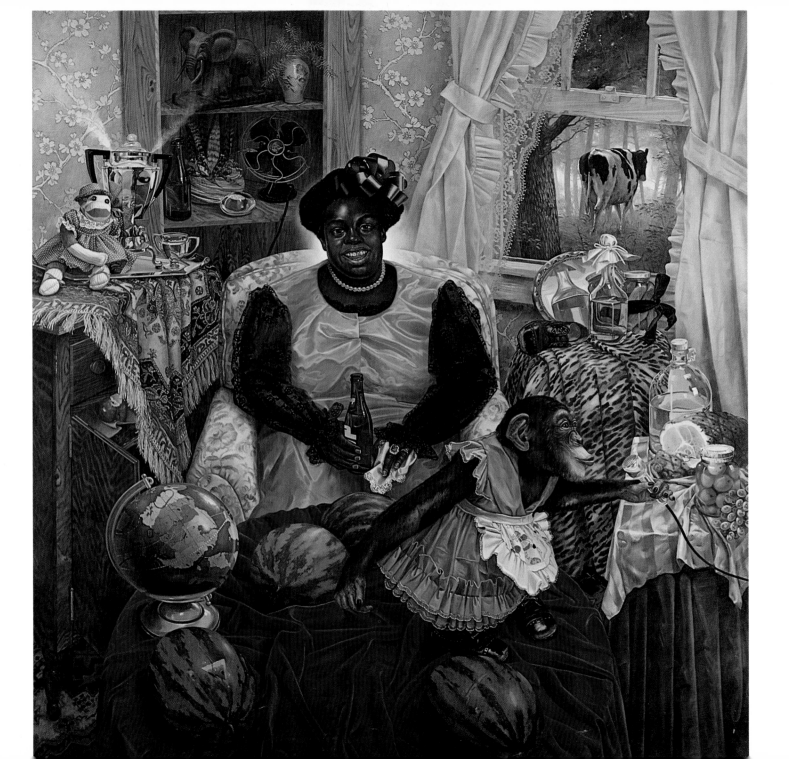

89

Title	CAR SIZED SHARK FOR WHITE
Medium	Oil on canvas
Size	Height: 20 inches Width: 22 inches
Signed	DONALD ROLLER WILSON JANUARY 25 · 1974 · 12:20 P.M. CAR SIZED SHARK FOR WHITE
Collection	THE BROOKLYN MUSEUM

90

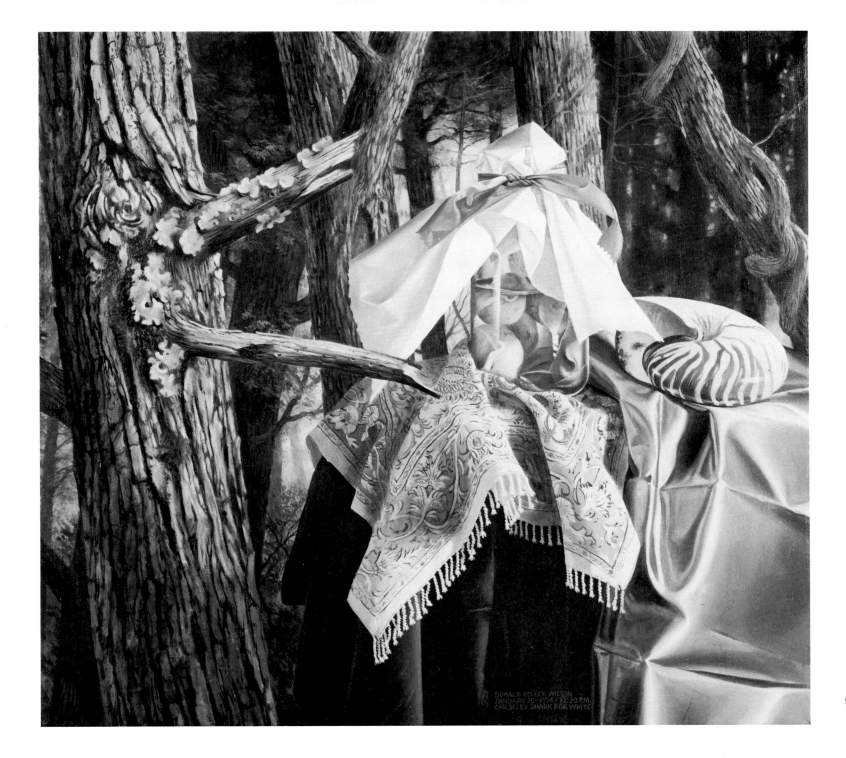

91

Title	SITTING IN THESE WOODS AND WAITING; HOPING THAT NO ONE WILL SEE; SUNLIGHT HITS MY GOLDEN BOTTLE; HOME IS BACK THERE IN THE TREES
Medium	Oil on canvas
Size	Height: 58 inches Width: 44½ inches
Signed	DONALD ROLLER WILSON SUNDAY · OCTOBER 14 · 3:00 P.M. 1973 · LIBRA
Collection	Wilds and Canon, Inc., Houston, Texas

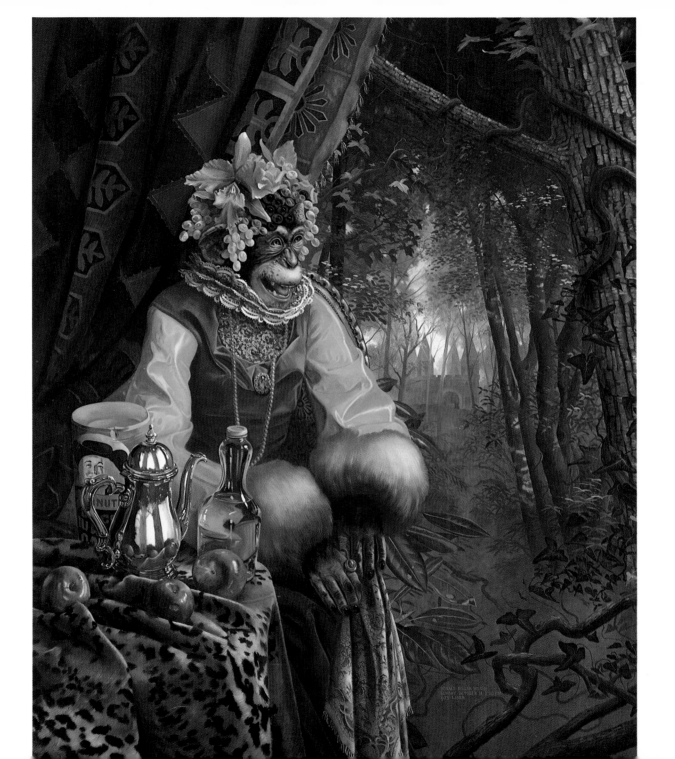

Title	WRAPPED UP IN THESE MOMENTS; WAITING; TOLD TO BRING THESE THINGS AND WAIT; SAD TO THINK THERE IS A DIFFERENCE; GOING THROUGH A THOUGHTFUL GATE
Medium	Oil on canvas
Size	Height: 48 inches Width: 48 inches
Signed	DONALD ROLLER WILSON AUGUST 14 · 1973 · LEO
Collection	Mr. and Mrs. Michael T. Judd

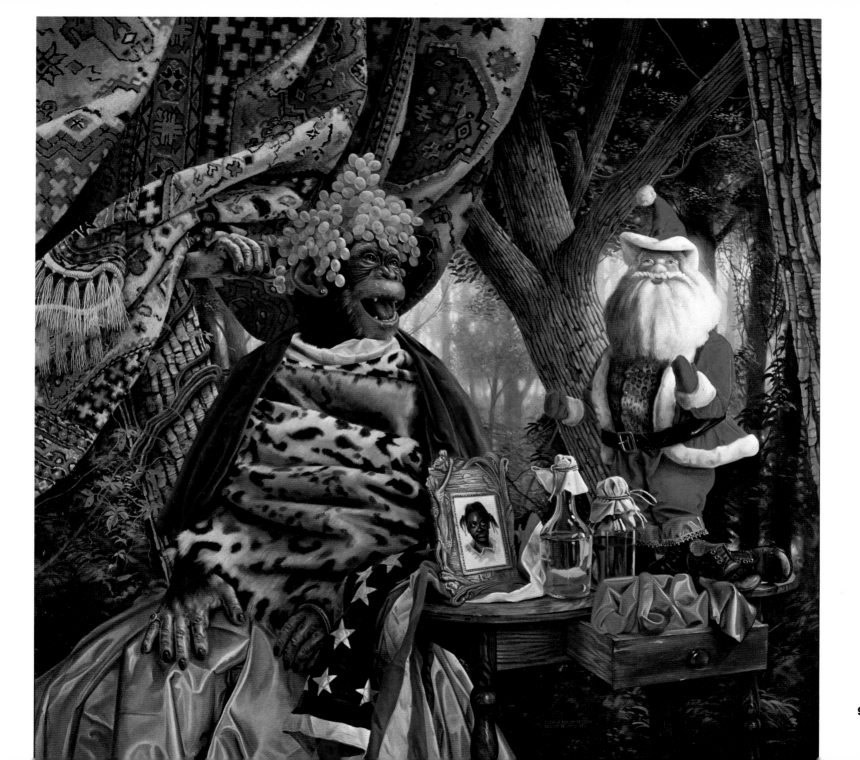

Title	LITTLE CHIGGER HUGS AUNT WHITE; IN THESE WOODS WHERE CARROTS GROW
Medium	Oil on canvas
Size	Height: 36 inches Width: 30 inches
Signed	DONALD ROLLER WILSON EARLY WINTER · 1973
Collection	Mr. James Julius Killough III

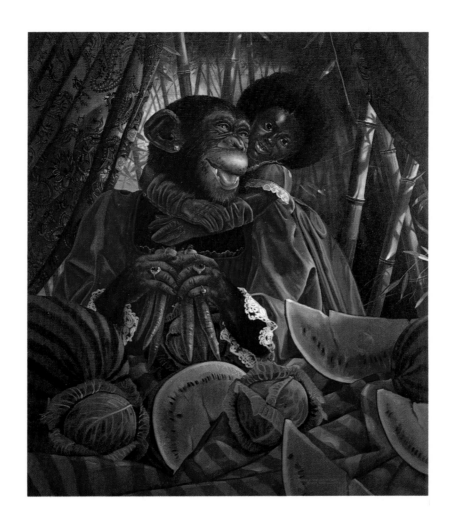

Title	TWO SWEET SINGERS IN THE WOODS; BETTY JANE AND HAZEL TOO; SING A SONG BEFORE YOUR WEDDING; FOREHEAD BLAZING LIKE THE BUSH
Medium	Oil on canvas
Size	Height: 66 inches Width: 60 inches
Signed	DONALD ROLLER WILSON FEBRUARY 7 · AQUARIUS · 1973
Collection	Mrs. Mills Bennett

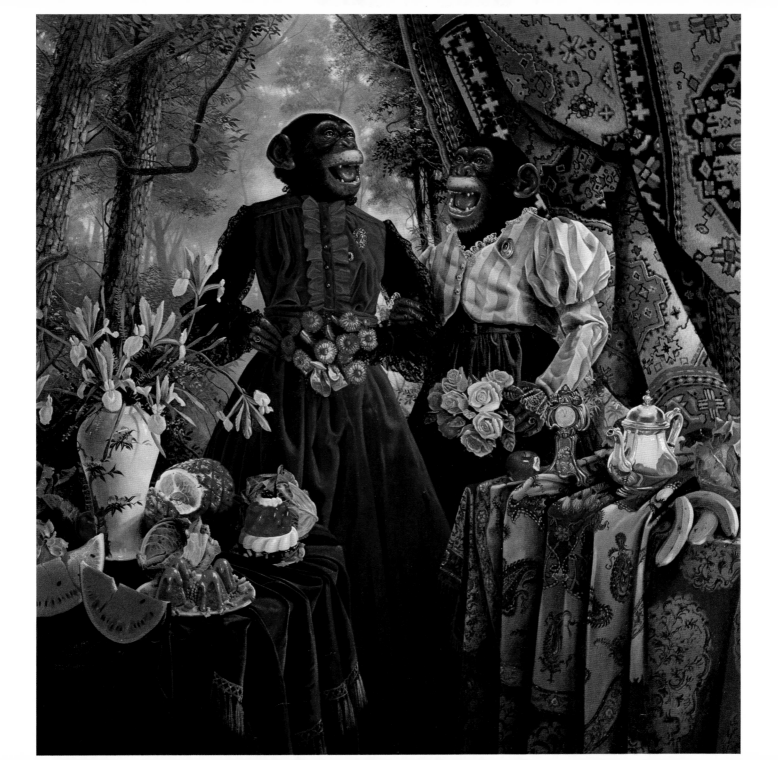

Title	SUNDAY SINGER—(MRS. WHITE); TIGER JOIN IN—SOUND A FRIGHT; LITTLE CHIGGER CHEW A FINGER, JACK-O, JELL—(OH! COMING NIGHT)
Medium	Oil on canvas
Size	Height: 66 inches Width: 84 inches
Signed	DONALD ROLLER WILSON SUNDAY · NOVEMBER 5 · 1972 · SCORPIO AND NOW KATHLEEN AND I ARE GOING FOR A NICE DRIVE IN THESE HILLS OF OUR HOME.
Collection	Mr. and Mrs. William Key Wilde

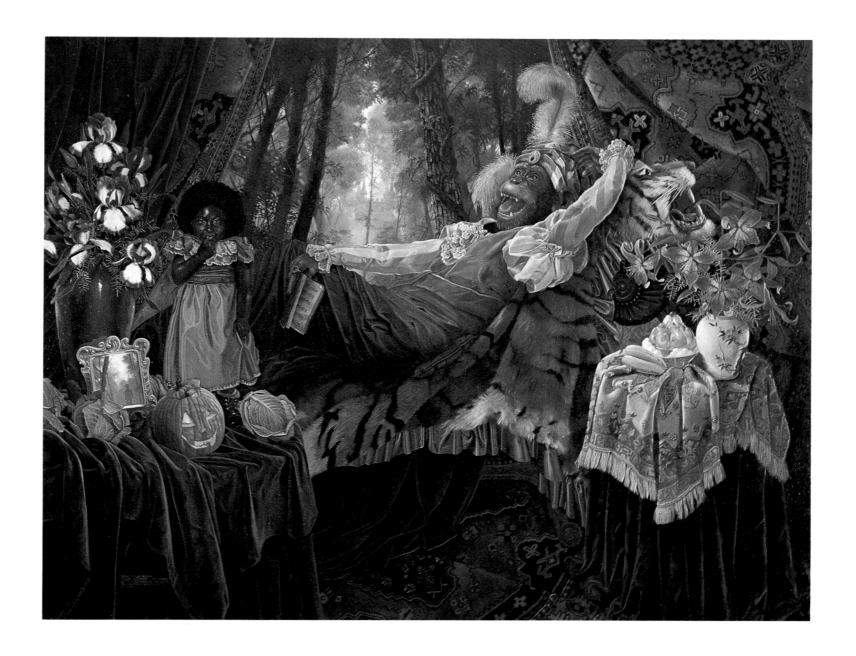

Title	AUNT WHITE SINGS AND PUSSY LISTENS;
	FRESH FROM MARKET: SUNDAY GOOSE
	IN THESE WOODS WHERE MY HEART LISTENS,
	TIGER HISSES—GLASS BALL GLISTENS
Medium	Oil on canvas
Size	Height: 96 inches
	Width: 66 inches
Signed	DONALD ROLLER WILSON
	OCTOBER 1, 1972, LIBRA
Collection	Mr. and Mrs. William R. Haynes

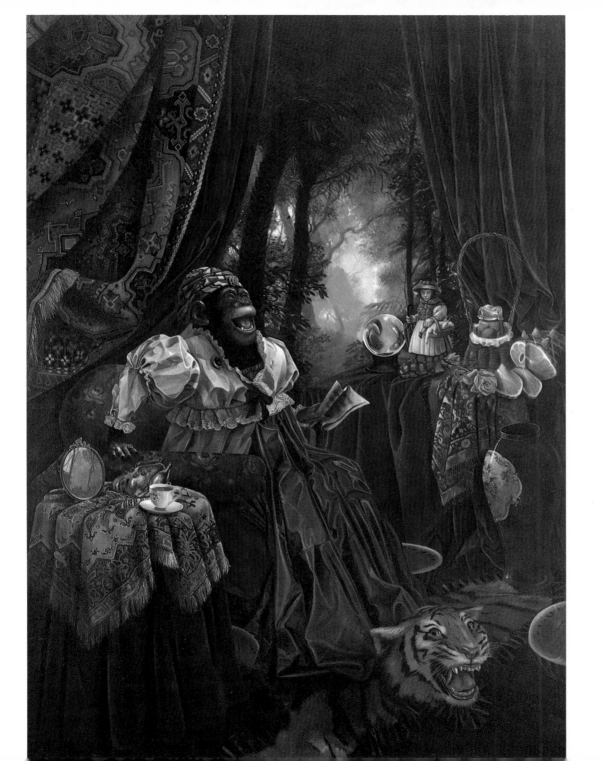

103

Title	NIGHT RIDE: CRISP SPEEDER
Medium	Oil on canvas
Size	Height: 10 inches Width: 12 inches
Signed	DONALD ROLLER WILSON SUMMER · 72
Collection	Mr. and Mrs. William Key Wilde

Title	SHIRLEY'S SLICE; SEEN AT NIGHT
Medium	Oil on panel (masonite oval)
Size	Height: 8 inches Width: 10 inches
Signed	DONALD ROLLER WILSON FRIDAY · SEPTEMBER 2 4:30 P.M. 1977
Collection	Segal and Maples, Houston, Texas

Title	MRS. WHITE SITS AND ROCKS; SMILES AND SMOKES WHILE BILLY GIGGLES—(LEFT HIS PUSSY IN THE WOODS)
Medium	Oil on canvas
Size	Height: 60 inches Width: 66 inches
Signed	DONALD ROLLER WILSON JUNE 29 · 1972 · CANCER
Collection	Mr. and Mrs. Robert Gay

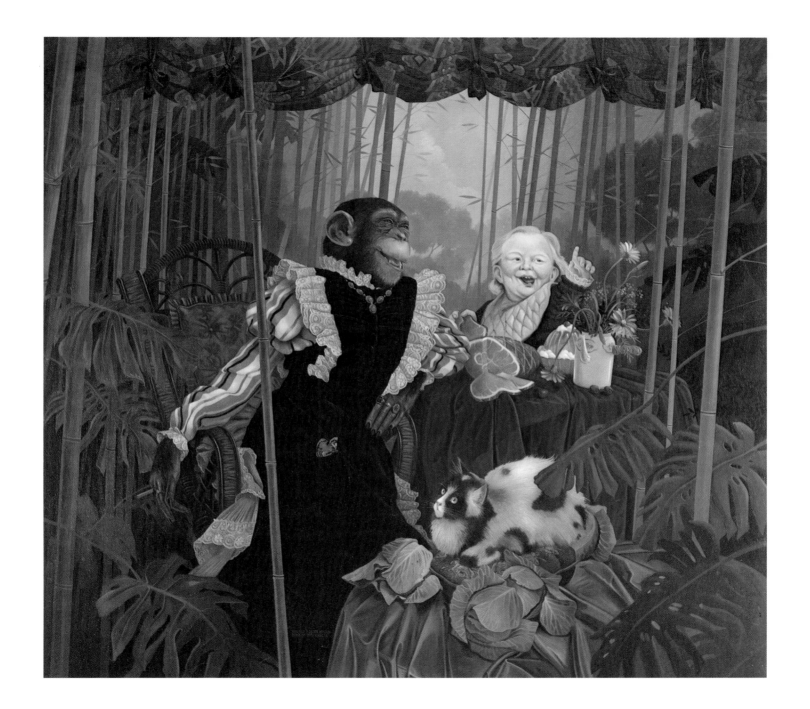

Title	LITTLE BETTY PEEKS AT MRS. WHITE BATHING; JELLO FLOATS AND SOFTLY LANDS
Medium	Oil on canvas
Size	60-inch equilateral triangle
Signed	DONALD ROLLER WILSON MAY 31 · 1972 · GEMINI
Collection	Mr. and Mrs. Cooke Wilson

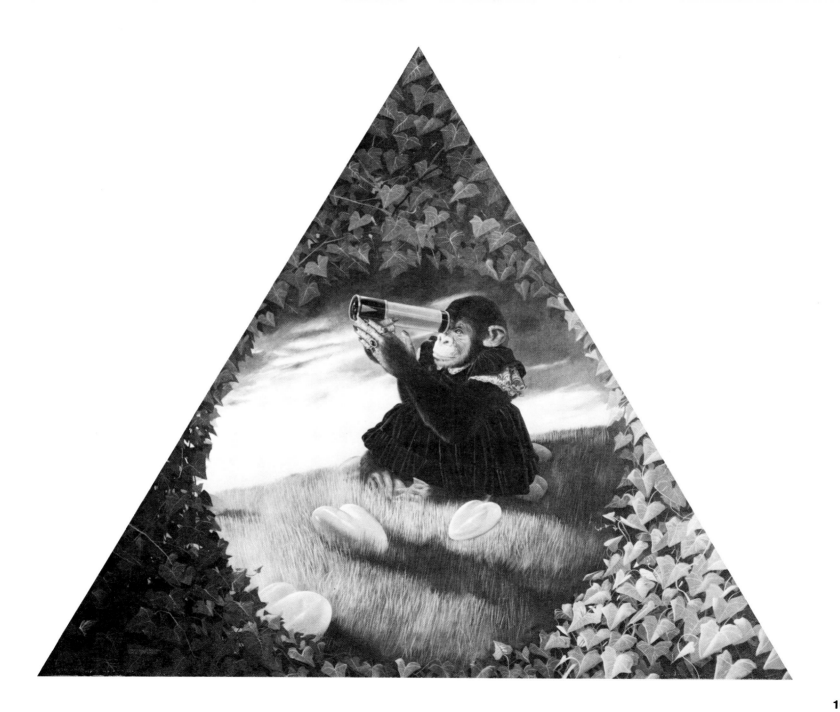

Title	AUNT WHITE AND MISS JEMIMA;ALL THE PARAPHERNALIA OF THE CRIME
Medium	Oil on canvas
Size	Height: 60 inches Width: 72 inches
Signed	DONALD ROLLER WILSON AUGUST 4 · 1971 · LEO
Collection	Mrs. Oscar C. Dancy III

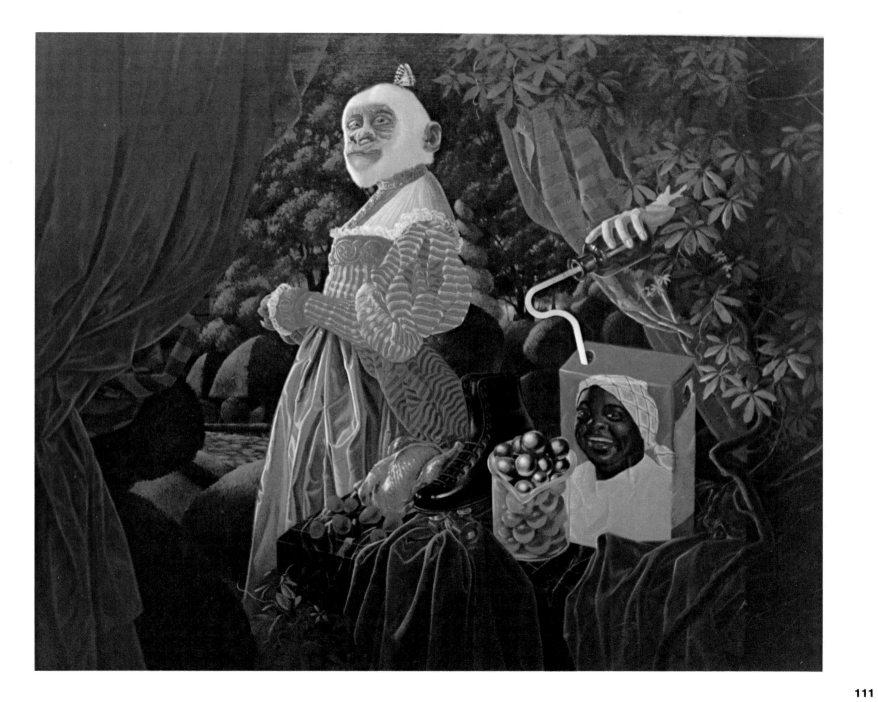

Title	KATHLEEN KAY'S DEAR FRIENDS AT MORNINGTIME
Medium	Oil on canvas
Size	Height: 60⅛ inches Width: 65⅝ inches
Signed	DONALD ROLLER WILSON · KATHLEEN'S FRIENDS AT MORNINGTIME · FEBRUARY 21 · 1971
Collection	Mrs. Oscar Dancy III

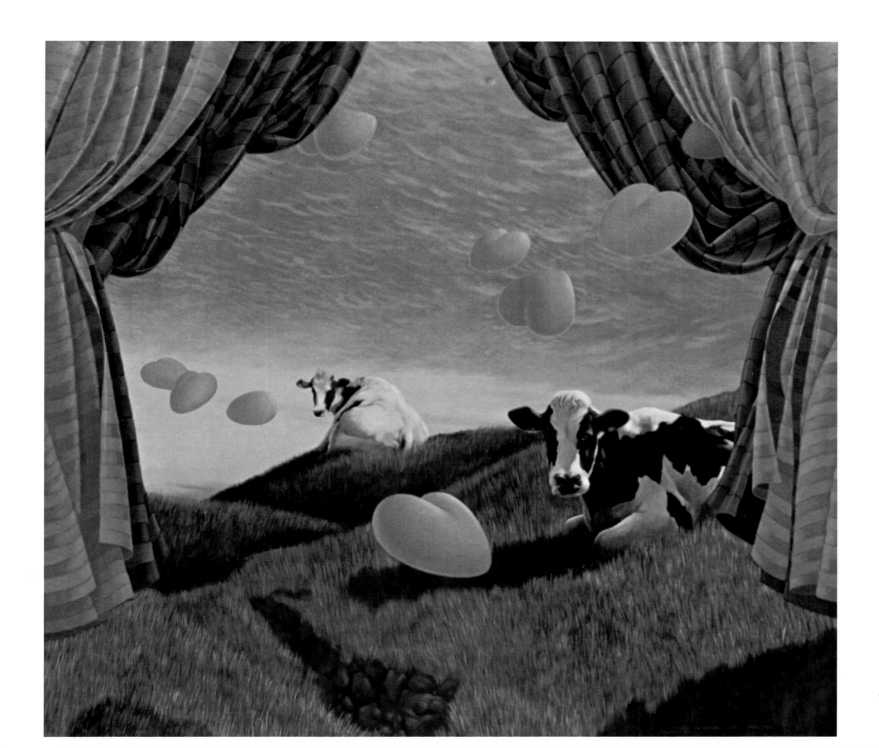

Title	HOLSTEIN—BLACK SWAN
	THE DEVIL MADE ME WEAR THIS DRESS
Medium	Oil on canvas
Size	Height: 60 inches Width: 48 inches
Signed	DONALD ROLLER WILSON JUNE 3, 1970
Collection	Marsha and Myron Wang

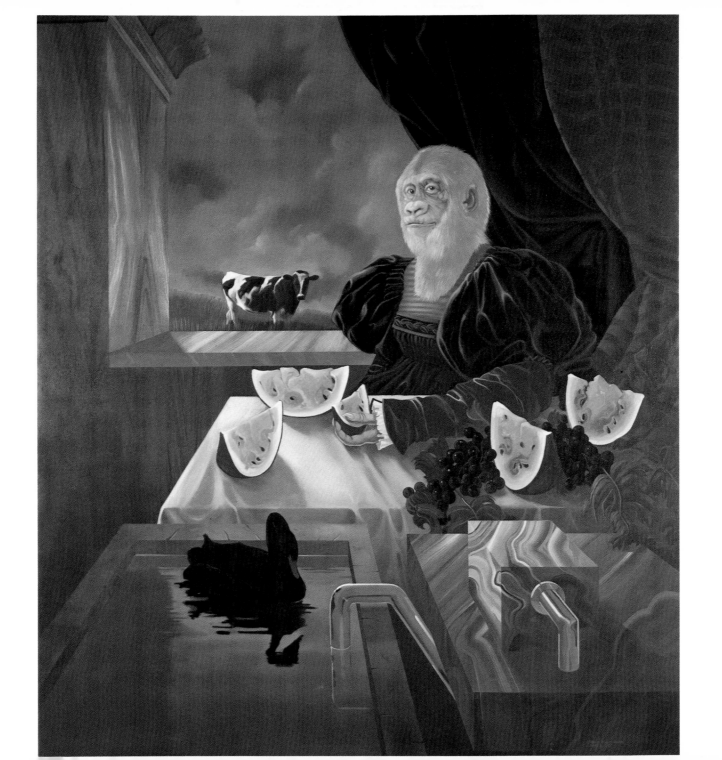

Title	COLD NIGHT; MY RABBIT—ME—A FRIEND; WE WERE READY WHEN THE SAUCER CAME
Medium	Oil on canvas
Size	Height: 66⅛ inches Width: 59⅞ inches
Signed	A CHICKEN AND HIS RABBIT FEBRUARY 28, 1970 DONALD ROLLER WILSON
Collection	Bruce and Judy Monical

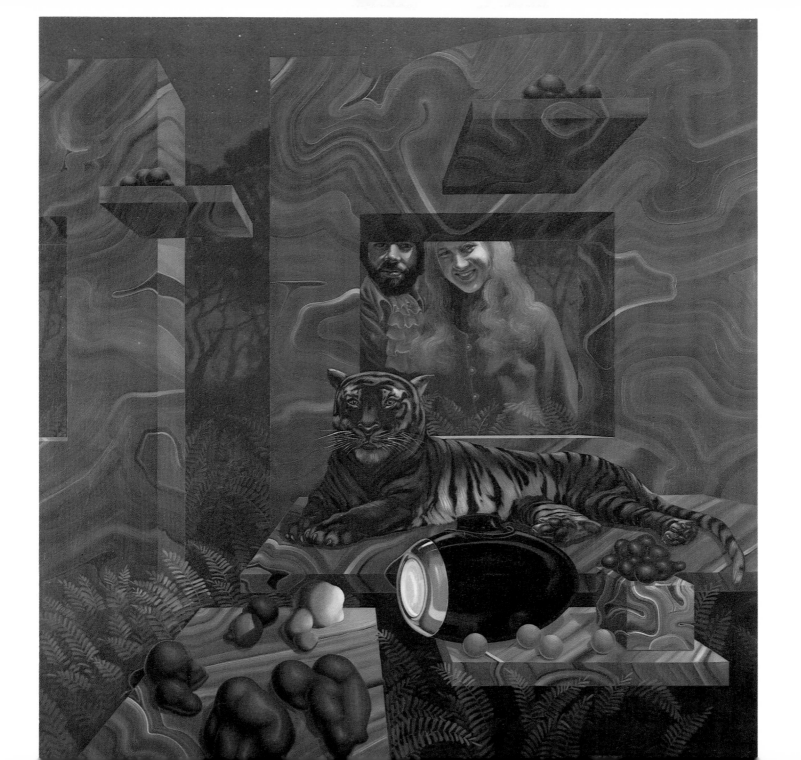

Title	PORTRAIT: KATHLEEN KAY: DEAR RABBIT
Medium	Oil on canvas
Size	Height: 72⅛ inches Width: 69 inches
Signed	FOR A SWEET RABBIT, PAINTED BY HER CHICKEN DONALD ROLLER WILSON OCTOBER 5th, 1969
Collection	Mrs. Oscar C. Dancy III

118

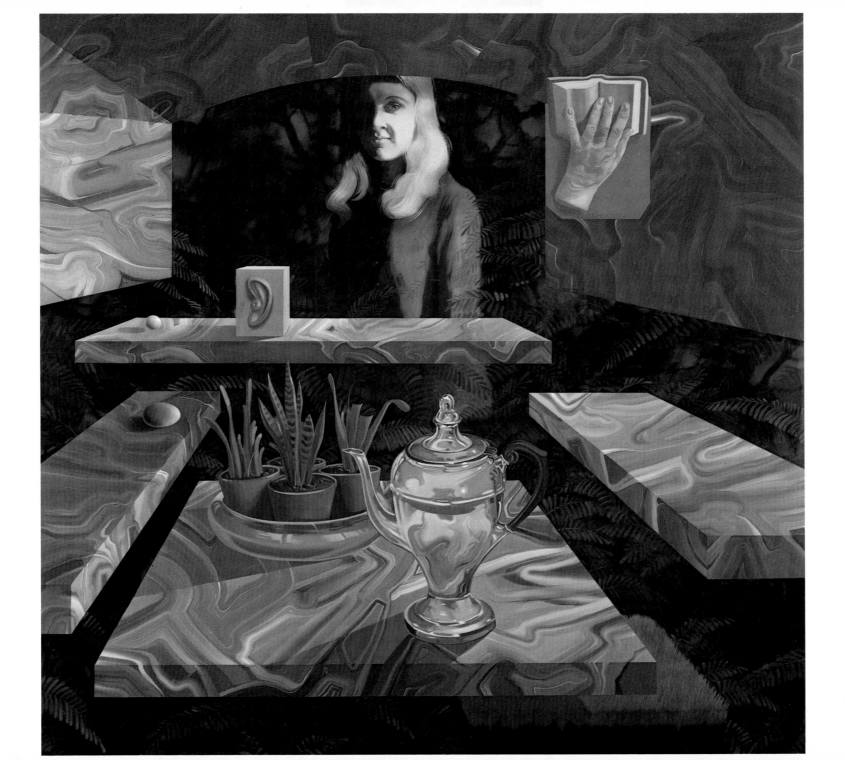

119

Title	RIVERBANK: DEAR WICHITA RABBIT; WHEN WE ALMOST KNEW
Medium	Oil on canvas
Size	Height: 60 inches Width: 48 inches
Signed	DONALD ROLLER WILSON,OCTOBER 31, HALLOWEEN, 1969
Collection	Mr. and Mrs. John Mecom, Jr.

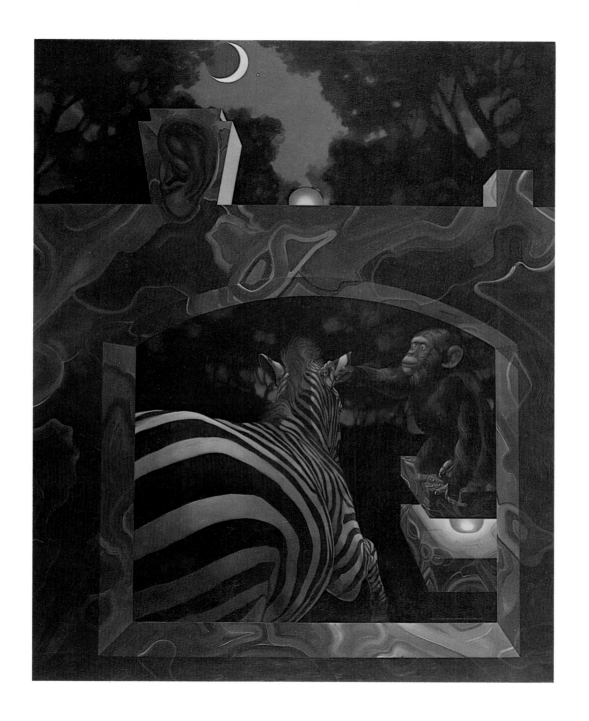

Title	PEA KING—OF THE MOUNTED STAR PATROL
	(CAUGHT STICKING A PEA IN HIS NOSE)
Medium	Oil on canvas
Size	Height: 60 inches
	Width: 63 inches
Signed	DONALD ROLLER WILSON 69
Collection	Mr. and Mrs. Carl Helmstetter

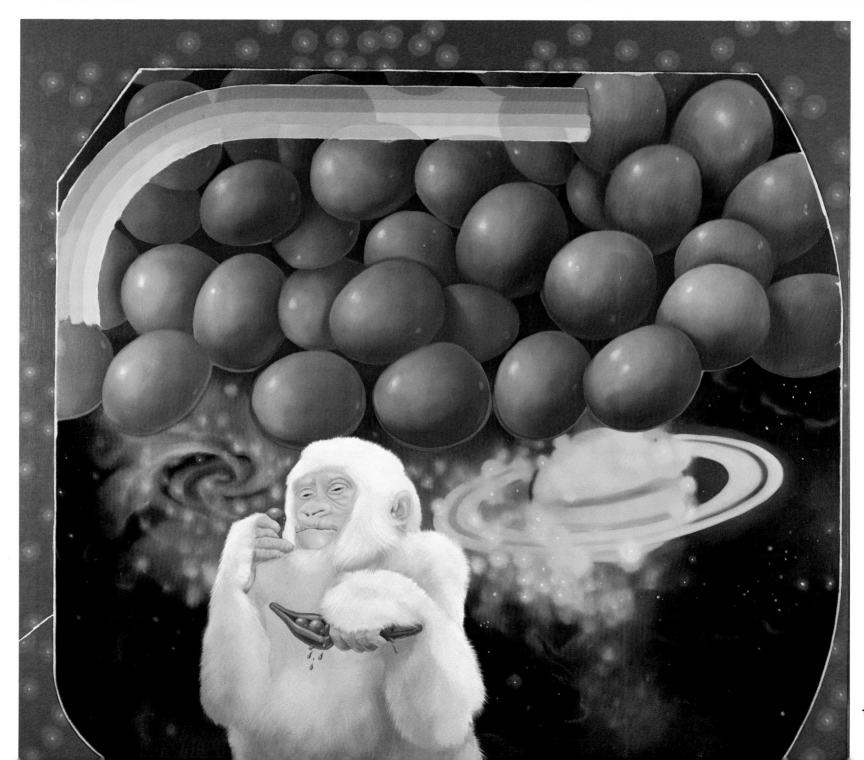

Title	MERCY LANDS CRIED JACK! WHAT'S COMING OFF HERE?
Medium	Oil on canvas
Size	Height: 72 inches Width: 66 inches
Signed	(W)
Collection	Mrs. Oscar C. Dancy III

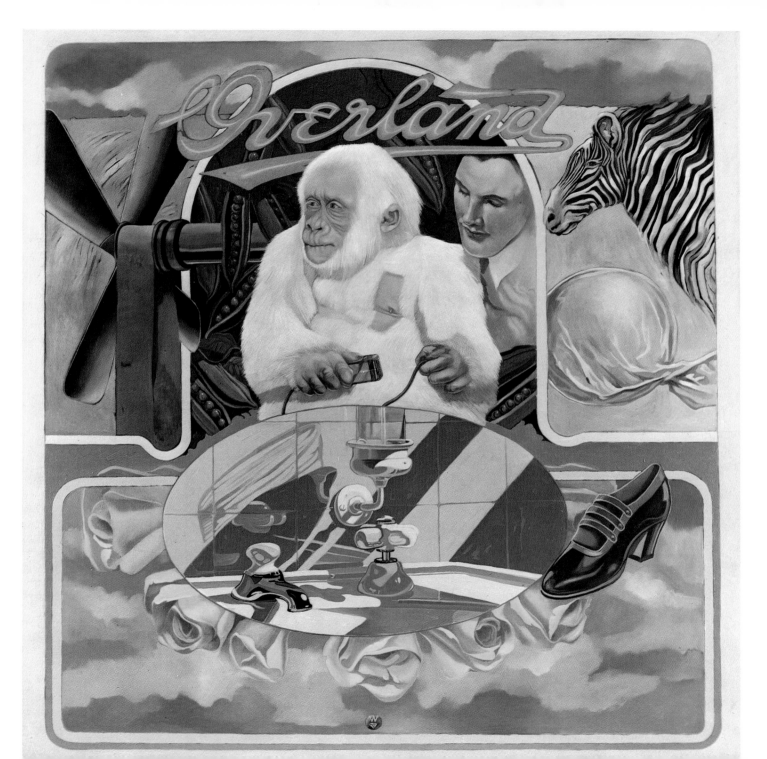

125

BIBLIOGRAPHICAL NOTES

GROUP EXHIBITIONS

1957 Air Capitol Exhibition, Wichita Art Museum, Wichita, Kansas

1959 Annual Competitive Art Student Show, Kansas State Teachers College, Emporia, Kansas (Purchase Award)

1963 Fifth Annual Exhibition of Southwest American Art, Oklahoma Arts Center, Oklahoma City, Oklahoma

1964 Fourteenth Mid-America Annual Exhibition, William Rockhill Nelson Gallery of Art and Mary Atkins Museum of Fine Arts, Kansas City, Missouri (Purchase Award)

Sixth Annual Exhibition of Southwest American Art, Oklahoma Arts Center, Oklahoma City, Oklahoma

Thirty-Fourth Annual Exhibition, Springfield Art Museum, Springfield, Missouri (Purchase Award)

1965 Eighteenth Annual Missouri Valley Exhibition of Oil Painting, Mulvane Art Center, Washburn University, Topeka, Kansas

Fifth National Print and Drawing Exhibition, Olivet College Festival of Fine Arts, Olivet College, Olivet, Michigan

Eleventh Kansas Artists Annual, Wichita Art Museum, Wichita, Kansas (Purchase Award)

Faculty Art Exhibition, Wichita State University, Wichita, Kansas (Acquisition of work)

Thirty-Second National Graphic Arts and Drawing Exhibition, Wichita Art Association, Wichita, Kansas

Fifteenth Mid-America Annual Exhibition, William Rockhill Nelson Gallery of Art and Mary Atkins Museum of Fine Arts, Kansas City, Missouri (Purchase Award)

California Society of Etchers National Print Exhibition, San Francisco Museum of Art, San Francisco, California

Thirty-Fifth Annual Exhibition, Springfield Art Museum, Springfield, Missouri

1966 Twelfth Kansas Artists Annual, Wichita Art Museum, Wichita, Kansas

Sixteenth Mid-America Annual Exhibition, William Rockhill Nelson Gallery of Art and Mary Atkins Museum of Fine Arts, Kansas City, Missouri (Purchase Award)

Third Annual "Selected Painters" Exhibition, Mulvane Art Center, Washburn University, Topeka, Kansas

National Small Painting Exhibition, University of Omaha, Omaha, Nebraska (Purchase Award)

1967 University of Nebraska Invitational Print Exhibition, University of Nebraska, Lincoln, Nebraska

Art of the Midwest Invitational Exhibition, William Rockhill Nelson Gallery of Art and Mary Atkins Museum of Fine Arts, Kansas City, Missouri

Four Man Invitational Exhibition (Burford, Eisentrager, Sampson, Wilson), University of Omaha, Omaha, Nebraska (Purchase Award)

Thirty-Seventh Annual Exhibition, Springfield Art Museum, Springfield, Missouri

Fourth Annual Selected Painters Invitational Exhibition, Mulvane Art Center, Washburn University, Topeka, Kansas

University of Arkansas Faculty Exhibition, University of Arkansas, Fayetteville, Arkansas

Hallmark Invitational Exhibition, Hallmark Card Company, Kansas City, Missouri

1968 Ball State University National Drawing Exhibition, Ball State University, Muncie, Indiana

Invitational Drawing Exhibition, William Rockhill Nelson Gallery of Art and Mary Atkins Museum of Fine Arts, Kansas City, Missouri
Art on Paper Invitational, Weatherspoon Art Gallery, University of North Carolina, Greensboro, North Carolina
The Fourth Annual Bucknell Drawing Exhibition, Bucknell University, Lewisburg, Pennsylvania

1969 Discovery 1969: The Mid-West Invitational, Hall's Gallery, Kansas City, Missouri
Sharon Behrends, James Davis, Donald Roller Wilson, University of Arkansas, Fayetteville, Arkansas

1971 Donald Roller Wilson with Jeffrey Allan Thomas, A Two-Man Exhibition of Paintings and Sculpture, The David Gallery, Houston, Texas
Mid-America Invitational Summer Exhibition, William Rockhill Nelson Gallery of Art and Mary Atkins Museum of Fine Arts, Kansas City, Missouri
Ozark Writers and Artists Guild Exhibition, Downtown Square, Fayetteville, Arkansas (Award)
Project South/Southwest Invitational Exhibition, Forth Worth Art Center Museum, Fort Worth, Texas

1972 Fourteenth Annual Invitational Painting Exhibition, Junior Service League, Longview, Texas
Faculty Exhibition, University of Arkansas, Fayetteville, Arkansas

1973 Ars Longa Galleries, Houston, Texas

1974 Douglas Drake Gallery, Kansas City, Missouri
Donald Roller Wilson with Bruce Monical, A Two-Man Exhibition of Paintings, Ars Longa Galleries, Houston, Texas

1975 1975 Biennial of Contemporary American Art, Whitney Museum of American Art, New York, New York

1976 Sixty-fifth Annual Exhibition of American Painting, Randolph-Macon Woman's College, Lynchburg, Virginia

1977 American Paintings and Drawings, John Berggruen Gallery, San Francisco, California
Little Egypt Enterprises, Moody Gallery, Houston, Texas
Recent Acquisitions, Hirshhorn Museum and Sculpture Garden, Smithsonian Institution, Washington, D.C.
A View of a Decade, Contemporary Art Museum of Chicago, Chicago, Illinois
Six Painters/Southwest, University of Oklahoma, Norman, Oklahoma
Downtown Dog Show, Fine Arts Museum of San Francisco, San Francisco, California

1978 Third Biennial Invitational Exhibition, Beaumont Art Museum, Beaumont, Texas
Art Center College of Design Invitational Painting Exhibition, San Francisco, California

PUBLIC COLLECTIONS

University of Arkansas, Fayetteville, Arkansas
Browning-Ferris Corporation, Houston, Texas
The Brooklyn Museum, Brooklyn, New York
The City Art Museum of St. Louis, St. Louis, Missouri
Commerce Trust Foundation, Kansas City, Missouri
Commercial National Bank, Nacogdoches, Texas
F. M. Hall Collection, Sheldon Memorial Gallery, University of Nebraska, Lincoln, Nebraska
Hirshhorn Museum and Sculpture Garden, Smithsonian Institution, Washington, D.C.
Kansas State College, Emporia, Kansas
Contemporary Art Museum, Houston, Texas
Jewett Arts Center, Wellesley College, Wellesley, Massachusetts
La Jolla Museum of Contemporary Art, La Jolla, California
University of Nebraska, Omaha, Nebraska
Nebraska State College, Peru, Nebraska
Neiman-Marcus, Inc., Dallas, Texas
William Rockhill Nelson Gallery of Art and Mary Atkins Museum of Fine Arts, Kansas City, Missouri
Springfield Museum, Springfield, Missouri
Thornton Foundation for the Arts, Kansas City, Missouri

Tulane University, New Orleans, Louisiana
Jane Wade Purchase Award Collection, William Rockhill Nelson Gallery of Art and Mary Atkins Museum of Fine Arts, Kansas City, Missouri
Wichita Art Museum, Wichita, Kansas
Wichita State University, Wichita, Kansas

INDIVIDUAL EXHIBITIONS

1964 Wichita State University, Wichita, Kansas
1966 Wichita Art Museum, Wichita, Kansas
1969 Sheldon Memorial Gallery, University of Nebraska, Lincoln, Nebraska
Contemporary Arts Museum, Houston, Texas
1970 The David Gallery, Houston, Texas
William Rockhill Nelson Gallery of Art and Mary Atkins Museum of Fine Arts, Kansas City, Missouri
Museum of Fine Arts, Kansas City, Missouri
The City Art Museum of St. Louis, St. Louis, Missouri
1972 Virginia Commonwealth University, Richmond, Virginia, Lecture and presentation of work
French and Co. Galleries, New York, New York
Northwest Missouri State College, Maryville, Missouri, Lecture and presentation of work
1973 Tibor de Nagy Gallery, Houston, Texas
1974 La Jolla Museum of Contemporary Art, La Jolla, California
1975 David Findlay Gallery, New York, New York
1976 University of Tulsa, Tulsa, Oklahoma, Lecture and presentation of work
Phillips University, Enid, Oklahoma, Lecture and presentation of work
1977 Moody Gallery, Houston, Texas
1978 University of North Dakota, Grand Forks, North Dakota, Lecture and presentation of work
John Berggruen Gallery, San Francisco, California
1979 University of Arkansas, Fayetteville, Arkansas, Lecture and slide presentation of work

♥

Editorial consultant: Sandra Choron

Production coordinator: Janet Hornberger

Designed by Emilio Squeglio

Type set in Helvetica by VAF House of Typography, Ltd.

Paper is cameo dull by S. D. Warren Paper Company

Separations by Bob Maygar, Gazlay Graphics, Inc.

Printed by Princeton Polychrome Press

Bound by A. Horowitz and Son